In Search of Norman Rockwell's AMERICA

HOWARD BOOKS
A DIVISION OF SIMON & SCHUSTER
New York London Toronto Sydney

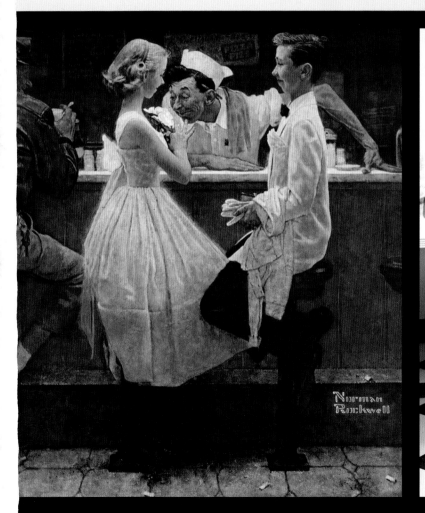

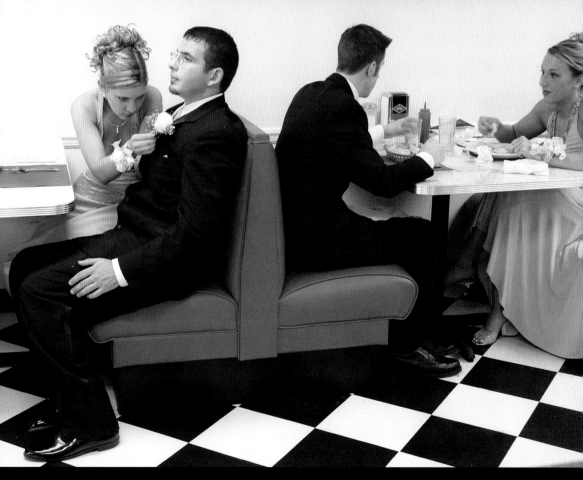

Photography by KEVIN RIVOLI · *Artwork by* NORMAN ROCKWELL

to my mother, *Josephine Rivoli*
my wife *Michele*
and our sons *Jack* and *Nick*

ACKNOWLEDGMENTS

One day I picked up a camera and decided I wanted to be a photojournalist. I had absolutely no training, so I set out to learn the craft on my own. Many would say I am self-taught. But no one really is self-taught. Even though I didn't study photojournalism in the traditional sense, I had much help along the way.

In Search of Norman Rockwell's America is a project made possible because of the mentoring I received and the relationships I developed over the past twenty years.

TO THE FOLLOWING I OWE MY GRATITUDE:

Jack Palmer, publisher of the first daily newspaper I worked for. The paper was a small-town publication, and all who worked there were like family. Jack was one of those rare managers of people. He believed in letting his employees do what they do best—their jobs. Never a micromanager, Jack understood what I needed to thrive in my profession. He allowed me to grow and chase my dreams. He supported my efforts as a visual storyteller and my aspirations to one day put my work into a book. *In Search of Norman Rockwell's America* is the end product of his stewardship as well as his friendship. Thank you, Jack.

David Connelly, my first managing editor. He is a brilliant man who was not only a wordsmith but a newsman with an understanding of photography as a means to tell the story, as well as an appreciation for it as an art form. He managed me with gentle guidance and trusted my instincts and eye. I will always appreciate that about him.

David Grunfeld, my photo editor and visual mentor. He is the most influential person with regards to helping me develop my photographic eye and visual style. We worked together for three visually intense years. Photography became a lifestyle during those days. With David's watchful eye and friendship, I set sail. Thanks, pal.

John Rockwell, president of the Norman Rockwell Family Agency; Mary Seitz-Pagano, licensing director of the Norman Rockwell Estate Licensing Company; Joan SerVaas and David Blackmer, CEO of Curtis Publishing Company and vice president of marketing, respectively. I thank you for all your support and hard work in making this book a reality. I most definitely could not have done this without you.

Amanda Cane and International Arts & Artists. Amanda, you believed in this project immediately and enthusiastically, and we are so happy to be working with you and your outstanding organization.

All the people who so willingly gave their time to share their thoughts about Rockwell. Your assistance was invaluable and shows the profound impact one man's work has had on so many lives.

All the individuals and institutions who have been so willing to lend Rockwell's work for our national traveling exhibition. Your generosity will allow so many across this country to experience firsthand the magnificent work of this American icon.

My mother—what a wonderful mother you are. After Dad passed away when I was eight, you took on the role of both parents. You never remarried. I know it wasn't easy for you. You dedicated your life to mine and worked hard to make sure I enjoyed my childhood and later years. You instilled in me a strong sense of family. I will always try to live up to the example you set. As this project has developed, I have been asked if I had a "Rockwellian" childhood. I did. And it's all because of you. I love you, Mom.

All of the people who have allowed me to document your lives —THANK YOU!

Chrys and John Howard, Stephanie Walker, and all the remarkable, talented folks at Howard Books. You have been incredible to work with and we appreciate all you have done for us!

All my family and friends—for your love and support. Words cannot begin to express how truly blessed we are for all of you.

Norman Rockwell, who has inspired me both personally and professionally and whose work continues to inspire millions. Without you, none of this would have been possible. A true artist and documenter of your time, you helped us all see our America as it was then and continues to be. You remind us all to truly embrace and celebrate the simple yet incredible moments in all our lives.

Michele, we have been on an unbelievable journey together for almost twenty years. We have beautiful twin boys and live a small slice of the American dream with peaks and valleys, as life often brings. We've weathered it all. You've been instrumental in getting this project off the ground. It was you who believed in it when I wasn't so sure. It was you who worked long hours, tirelessly putting all the intricate pieces together that form this amazing project. I would never have been able to do this without you. Your love for me is awe-inspiring, truly. How lucky I am to share life with you.

Jack and Nick, two extraordinary little boys who have made me appreciate the simple things in life. I forgot what it was like to enjoy life's firsts until you guys showed up. Being your dad is the most important job I will ever have. I hope I do right by you both. May the message of this book— hope, faith and embracing the simple things in life—stay with you always. This is my legacy to you.

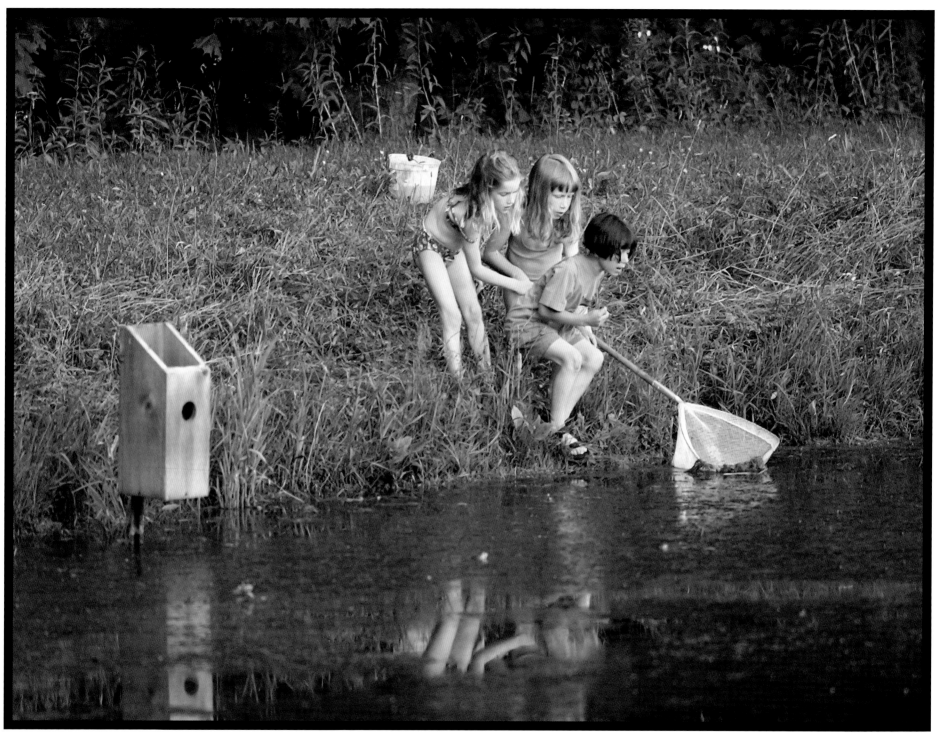

Catching Frogs

FOREWORD
Rockwell, Photojournalism and the Discovering of Everyday America

Andrew L. Mendelson, Ph.D.

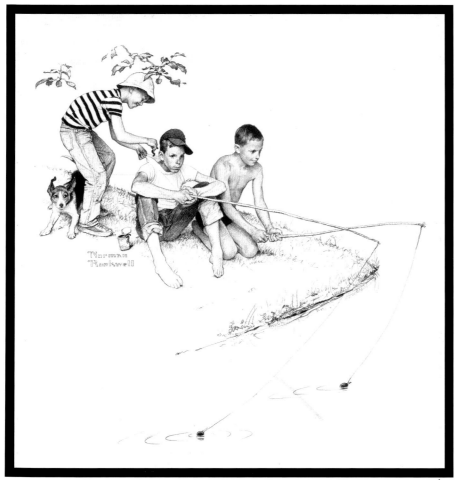

Boys Fishing

IN ONE SCENE, it's a perfect summer day. Three girls balance precipitously on the banks of a pond, all grasping a single net, trying to snare a frog. Behind them sits a bucket ready to hold their catch. In another scene, it's another perfect summer day. This time three boys sit on the edge of a pond with fishing poles, likewise hoping for a catch. One of the boys drops a worm down the back of his friend's shirt. Both scenes represent moments of adventure and leisure for children freed from the stresses of school and adults. Both scenes are frozen in time as if something is about to happen, what the great French photojournalist Henri Cartier-Bresson called the decisive moment. Both scenes are captured vividly by artists, one a painter, the other a photojournalist, many years apart. The artist was Norman Rockwell; the photojournalist, Kevin Rivoli.

Despite the differences in time period and medium, Rockwell and Rivoli have much in common. A common thread of aesthetics and subject matter runs through the work of these two artists, a thread that focuses on those slices of life moments, the lighthearted joy of everyday people. More than anything, this connection between Rockwell and photojournalism suggests that Rockwell taught photographers and viewers how to see, what to value, and what is worth recording and looking at over and over again. So it is not surprising that photojournalist Kevin Rivoli makes photographs that capture the same moments that captivated Rockwell.

It is a visual language Rockwell created almost one hundred years ago. Rockwell was born in 1894 in New York City

and trained as an illustrator, an artist whose work was geared more for commercial or mass media outlets than galleries. By 1916 he had begun work as a cover illustrator for *The Saturday Evening Post*, the publication that more than any other would define him. Even his earliest covers show a split from previous and contemporary cover illustrators. Artists such as Howard Pyle and N. C. Wyeth, who came before Rockwell, focused more on heroes and fantasy, not the everyday scenes Rockwell favored. More contemporary artists such as J. C. Leyendecker and Charles Dana Gibson focused on the elite of society, beautiful and polished people readers could aspire to emulate. But Rockwell was different, drawing his subject matter from the life of everyday folk, both in the city and in the small town, adding in humorous twists.

Over a career that spanned more than sixty years and three hundred *Saturday Evening Post* covers, as well as extensive work for a variety of other outlets, Rockwell showed Americans "the America I knew and observed to others who might not have noticed"[1]—an idyllic place that emphasized community and family, kids playing, and neighbors chatting. His images were painstakingly constructed from his keen observations of the places in which he lived, combined with his own insights, often using his neighbors as models. Rockwell tried to capture the humor of everyday scenes in American life, to hold up these commonplace scenes for appreciation. Rockwell himself explained: "The view I communicate in my pictures excludes the sordid and the ugly. I feel my work is popular for this reason. Ours is a frightening world and people are reassured by simple human decency."[2]

More than anything, Rockwell was a visual storyteller, constructing complete scenes, what author Christopher Finch calls "little dramas,"[3] so viewers would be able to recognize what came before and after the displayed situation. His characters are not strangers to us. We've met them before both in real life and in visual depictions. Rockwell's images are pieces of a larger tapestry of American life.

Rockwell created images that portrayed common everyday folk, rather than the famous or infamous. As art critic Michael Kimmelman writes: "Rockwell gave us a people's history of America during the first half of the century. It was not a history of celebrities and presidents, but of Aunt Ella taking her niece for a ride in a horse-drawn carriage, and of Dad and Mom driving Grandma and the kids to their summer vacation in a crowded Packard with the family's green rowboat strapped to the car, and of a new television antenna being installed on the gabled roof of an old Victorian house with a church steeple in the distance—old religion giving way to new."[4]

Rockwell's early work is more likely to exaggerate the humorous through larger gestures and expressions. In addition, Rockwell often placed his subjects against a plain background, limiting contextual information. This can be seen in an early image of two boys playing leapfrog. The scene is almost hyperreal, with the leaping boy wearing a broad expression of excitement, while a dog bounds next to them, all set against a plain white background. Rockwell's later work is more nuanced and poignant, placing subjects in a complete setting. An excellent example is *Shuffleton's Barbershop*. The viewer is voyeuristically looking through the window of a peeling door of a small-town barbershop at night. The front of the store is dark, but a back room is aglow with amateur musicians. The viewer sees parts of three of the musicians. No exaggerated expressions are seen. The scene is one of quiet mood and the fine detail.

While in some ways dateable by the attire and hairstyles, Rockwell's scenes are timeless, expressing visually enduring narratives about American life. By publishing for mass audiences, Rockwell visually encapsulated and emphasized themes important to Americans. These themes have been repeated by other artists, writers, and photographers over time, becoming a visual language for conveying national narratives. Today, few publications utilize illustrators for their cover art, and those that do, do not focus on these moments. But this Rockwellian visual language is not lost. It has been incorporated gradually into the work of photojournalists, especially newspaper photographers, over the past sixty years.

Like Rockwell imagery, the feature photograph, a category of news photography, focuses on those timeless moments of everyday life in a photographer's community. These scenes usually are not tied to any pressing news event, but instead show more positive sides of life, especially those with a humorous note. Because of their timeless nature, feature photographs often are not published immediately after they are taken, nor are they likely to run with a specific story.

The concept of documenting the everyday aspects of life, as in Rockwell's work, was not part of the photographic repertoire of the nineteenth century. It was not possible to capture the spontaneity

required for a Rockwellian moment due to the required long exposures and heavy equipment used. When middle-class families were documented in pictures, it was most often in formal portraits, with subjects dressed in their finest attire and posed in front of plain backgrounds. There was little thought of capturing everyday life. People wanted to record themselves at their best, not as they normally would be seen.

Spontaneous photojournalism of everyday life became possible with the invention of high-speed lightweight cameras such as the Ermanox or the Leica in the mid-twenties. This followed the earlier invention of the Kodak Brownie camera and snapshot photography around 1900, which democratized visual representation. People began to photograph anything and everything.

The Rockwellian look of feature photographs dominates all conceptions of feature photographs by the 1960s. As one photojournalism textbook from the time states, "feature assignments call upon the photographer to uncover the appeal in what is generally regarded as the dull routine of everyday life." [5]

More recently, Kenneth Kobre, author of a leading photojournalism textbook, explained that "feature photos provide visual dessert to subscribers who digest a daily diet of accidents, fire, political, and economic news. . . . [they] record the commonplace, the everyday slice of life. The feature photo tells an old story in a new way," often providing a more humorous or optimistic view than a news photo does.[6]

The key to a good feature photograph is a spontaneous situation focused on one aspect of everyday life. Photojournalist Dave Labelle even cites Rockwell as an example photojournalists should emulate: "Norman Rockwell didn't paint pictures; he painted moments."[7] Terms such as "slice of life" and "human interest" are found repeatedly in photojournalism textbooks and trade magazines. Many writers on photojournalism emphasize the need for strong emotion, especially humor.

It is within this Rockwellian tradition of feature photography that Kevin Rivoli's work clearly falls. Rivoli's inspiration comes from the small towns of upstate New York. He makes photographs that reveal the same types of scenes Rockwell made famous, helping his readers appreciate and better understand who they are.

Rivoli's photographs, like Rockwell's paintings, capture scenes of everyday life. We see many of the same characters that Rockwell documented: children playing, young people courting, neighbors chatting, and people working, all captured humorously and poignantly. Rivoli is not interested in recording the activities of the famous. We see regular folk, mostly coming together in informal public spaces such as diners, barbershops, parks, and front porches.

Rivoli did not consciously intend to reproduce Rockwell's work. But the enduring power of Rockwell's visual aesthetic is revealed in Rivoli's work of the present, portraying themes and values to which readers continue to respond. While each Rockwell image took hours to create, each of Rivoli's images was created in a fraction of a second. Still, Rockwell's and Rivoli's artistry is rooted in broader values, in a modern American nostalgia for a "better" life—or at least a modern desire to glimpse the simple slice-of-life moments that emphasize human nature at its most positive. Rockwell's artwork and Rivoli's photography capture a timeless humor and innocence, through the illumination of moments that reveal the human spirit. What we recognize in both Rockwell's and Rivoli's works are scenes that confirm the values to which Americans aspire.

ANDREW MENDELSON *is an associate professor in the department of journalism in the School of Communications and Theater at Temple University. He writes on the ways people understand the world through photographs, examining various psychological and social factors that affect viewers' interpretations. His teaching connects closely with this research, focusing on visual literacy and documentary photography. He holds a Ph.D. in journalism from the Missouri School of Journalism.*

Notes for this foreword appear on page 128.

INTRODUCTION

Kevin Rivoli

COMMONPLACES never become tiresome. It is we who become tired when we cease to be curious and appreciative . . . We find that it is not a new scene which is needed, but a new viewpoint." Norman Rockwell made that statement more than seventy years ago, but the point he made then is still relevant today—maybe even more so.

One of the most important lessons I've learned from Rockwell and his work is that life isn't always about moving to new places to find new things. And it isn't about having the biggest and the best and the most. Life—real life—is about looking at, appreciating, and embracing the simple things that are right in front of us. Rockwell was a man who made it his mission to celebrate the ordinary. And although he was immensely popular among the American people, his work was often dismissed by critics who deemed his work old-fashioned and too idealistic, or sentimental and overly nostalgic. He was accused of creating moments that didn't exist or—as one critic alleged—of "creating an America that never was and never will be."

Rockwell disagreed, once saying, "Without thinking too much about it in specific terms, I was showing the America I knew and observed to others who might not have noticed." While Rockwell often painted from staged photographs he personally choreographed, he created those images based upon his life experiences and what he saw going on in the world around him.

The America that Rockwell painted did—and still does—exist. I know because I've spent the last twenty years as a photojournalist documenting spontaneous moments in all areas of life. I've photographed picture stories relating to death, destruction, and human despair. And of course there is a need for that. But there's also a need for the other perspective. Maybe it's because I am older or am now a father, but I realize, and want my children to know, what life is and isn't. While they need to understand what is wrong in this crazy world we live in, I want them to focus on what is right and what is possible. I want them to enjoy a childhood filled with wonderful memories in the making. I want them to embrace the simple moments that can and do happen every day. And I want them to laugh.

When this project started to take shape a couple of years ago, we decided to pursue putting the work in a book as well as a national traveling exhibition. We were rejected by the first two organizations we contacted to handle the tour. The first told us that "it's way too upbeat and Americana for us to get involved," while the second told us that "the work is very nice, but we only do serious photojournalism on relevant social issues. This is just too upbeat, too happy for what we do." At first we were stunned. Too happy? Although it's funny to think of now, it is also such a sad statement on what some think American society has become.

When we shared this with John Rockwell, Norman's grandson, he pointed out that his grandfather "very deliberately chose the images he wanted to portray." And while Rockwell's work varied, and at times addressed serious social issues, much of the work he chose to focus on was chosen because it accentuated the positive. "To appreciate an artist, you should look at the artist and try to understand what he is trying to do," John Rockwell said. "Pop felt strongly about trying to bring attention to the positive aspects of our everyday world because he felt it was a part of the fabric of America. Kevin's photographs help us do that."

John's words prompted us to press on. And we're so glad we did.

When a good friend of ours reviewed the initial mock-ups of the book and art chosen for the touring art show, he looked at one image and said, "I've probably seen that happen a million times before but never paid attention. Now that I've seen it like this, I'll take notice and remember it."

That's what we hope for.

This project reminds me every day to slow down and pay attention to what is going on around me. It makes me pause to enjoy the sight of my sons as they catch their first fireflies and look amazed as the fireflies shine in their tiny hands. It makes me remember all that is right in this world. The Rockwell family and I hope it does the same for you.

The *In Search of Norman Rockwell's America* project has been—and continues to be—an amazing journey. We've had the pleasure of meeting and working with some of the most incredible people from all walks of life, who, regardless of gender, race, religion or socioeconomic background, admire the work of a man who made it his mission to celebrate the ordinary—or as he said, "the things we have seen all our lives and overlooked."

We thank Norman Rockwell for the impact he has had on our lives and realize that he's right: maybe it is time for a new viewpoint.

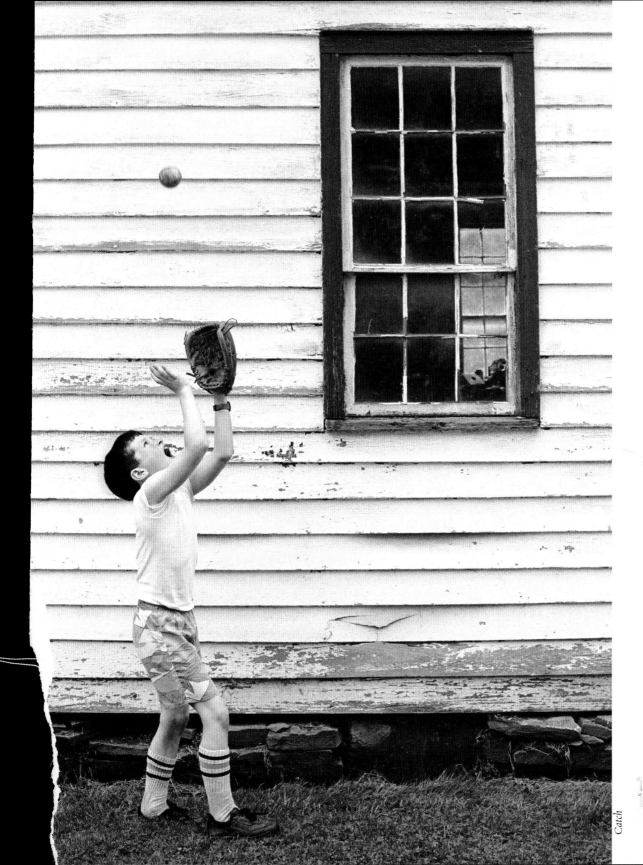

COMMONPLACES NEVER
BECOME TIRESOME.
IT IS WE WHO BECOME TIRED
WHEN WE CEASE TO BE CURIOUS
AND APPRECIATIVE . . .
WE FIND THAT IT IS
NOT A NEW SCENE
WHICH IS NEEDED, BUT A NEW
VIEWPOINT.

—*Norman Rockwell*

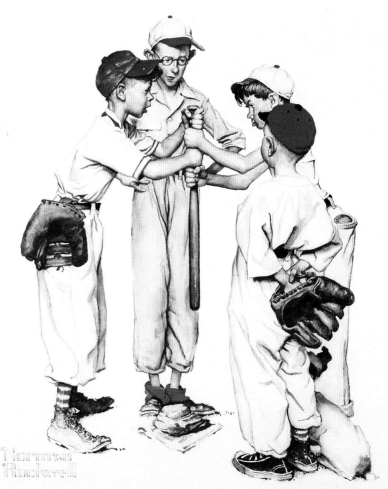

Catch

Choosin' Up

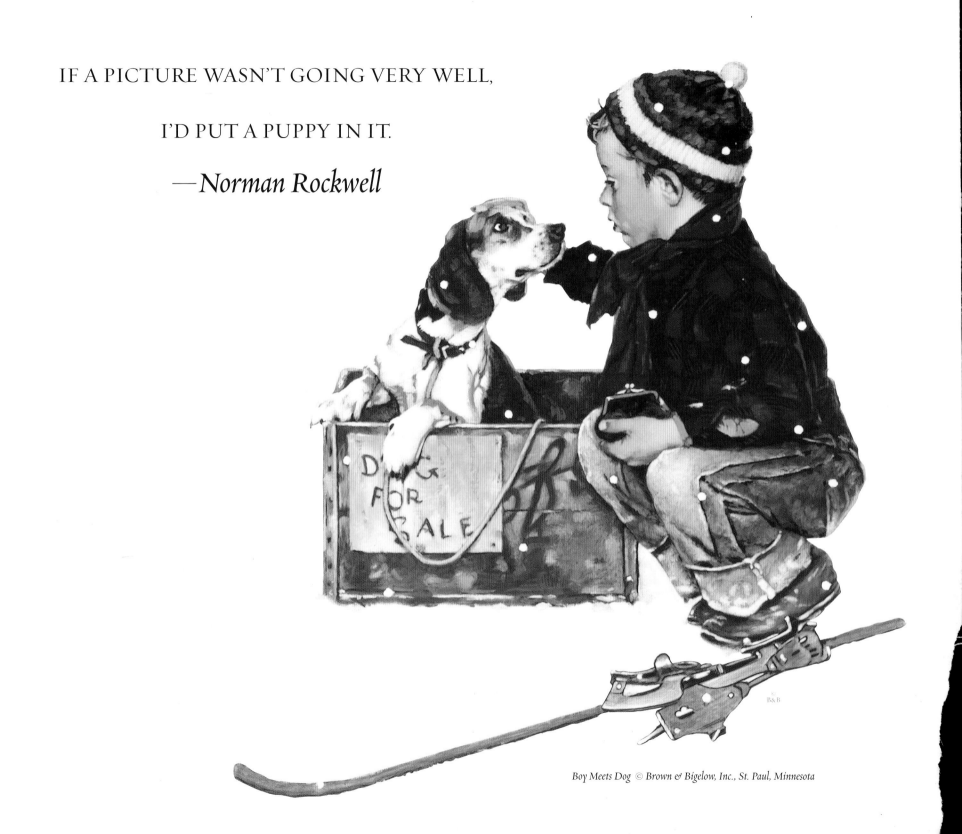

IF A PICTURE WASN'T GOING VERY WELL,

I'D PUT A PUPPY IN IT.

—*Norman Rockwell*

Boy Meets Dog © *Brown & Bigelow, Inc., St. Paul, Minnesota*

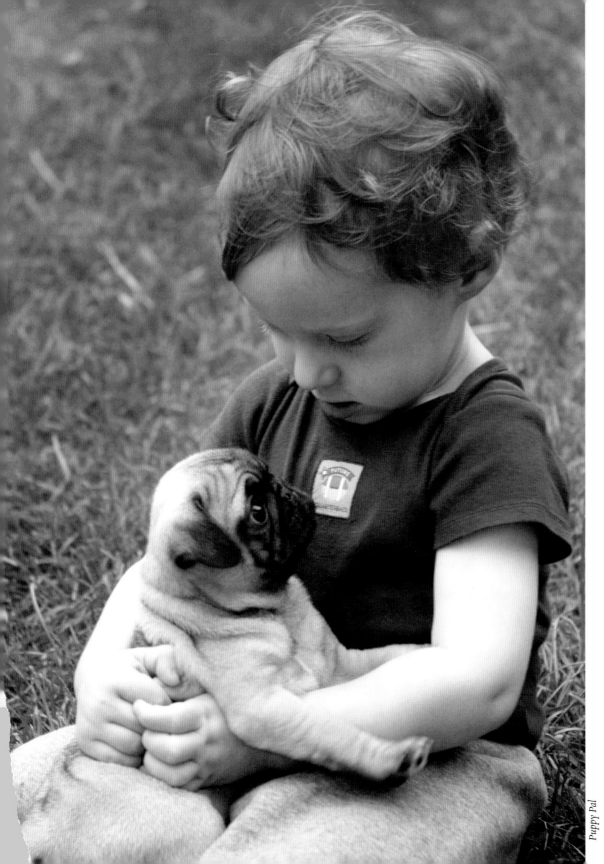

Puppy Pal

What does an image mean? Why do some images stay with us through time, and others are forgotten faster than a thundershower? I don't know. I know that my grandfather's images have lasted past his lifetime and I often meet people that speak fondly of his work, almost as if he was their grandfather as well. Some of this is a common reaction to fame in our culture: somehow the famous belong to all of us. Some of this, though, is due to a fondness that Norman's images engendered. He chose to portray, for the most part, a world that was safe, simple, accessible, and joyful. I think we can all remember, and often long for, times when the sight of Christmas presents or an afternoon at the local fishing hole was enough to make us happy.

I think it was this quality that inspired Kevin Rivoli's photographs and was the seed for this book. There are a plethora of images of destruction out there. We have become almost immune to them. Kevin's photographs and Norman's works remind us that there are also a multitude of moments we can feel good about and celebrate, moments that we often overlook.

—*John Rockwell*
Norman's grandson and president of the Norman Rockwell Family Agency

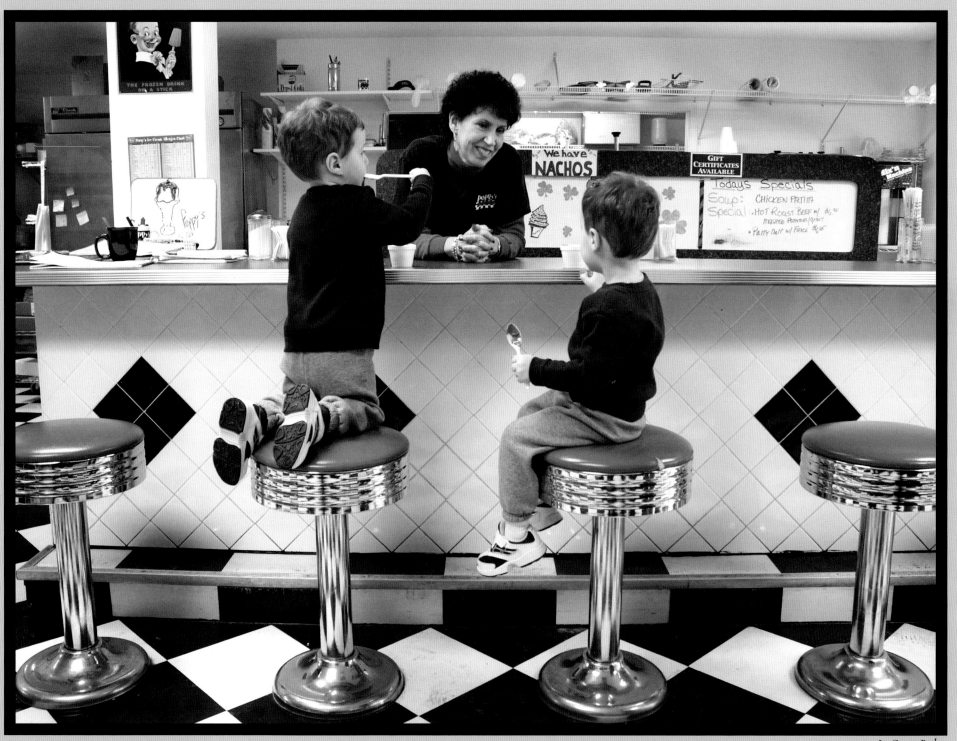

Ice Cream Parlor

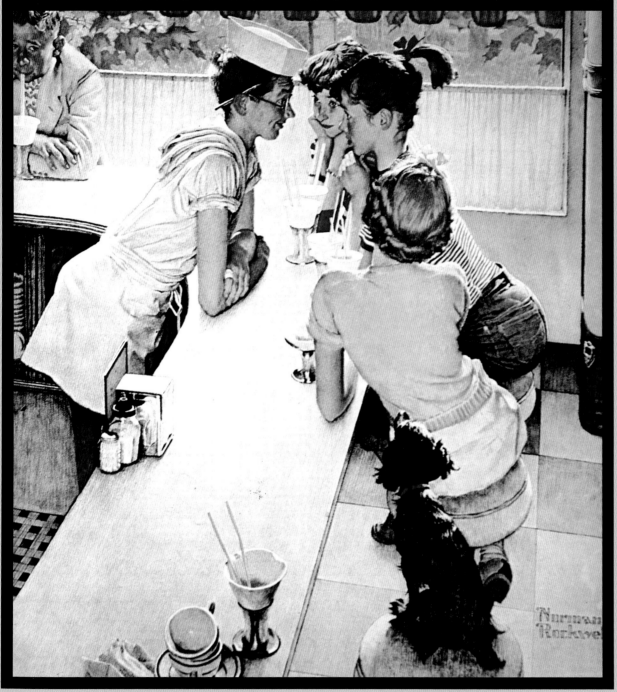

Soda Jerk © 1953 SEPS

NORMAN ROCKWELL'S WORK CELEBRATES ORDINARY MOMENTS IN LIFE—MOMENTS WE CAN ALL IMMEDIATELY UNDERSTAND AND FEEL CONNECTED TO IN ONE WAY OR ANOTHER. HE SHOWS US THAT THE ORDINARY CAN BE EXTRAORDINARY AND REMINDS US TO SLOW DOWN AND EMBRACE THE AMAZING, SIMPLE MOMENTS THAT HAPPEN IN OUR EVERYDAY LIVES.

—*Lee Iacocca*
American businessman best known as the former
chairman of Chrysler Corporation, author

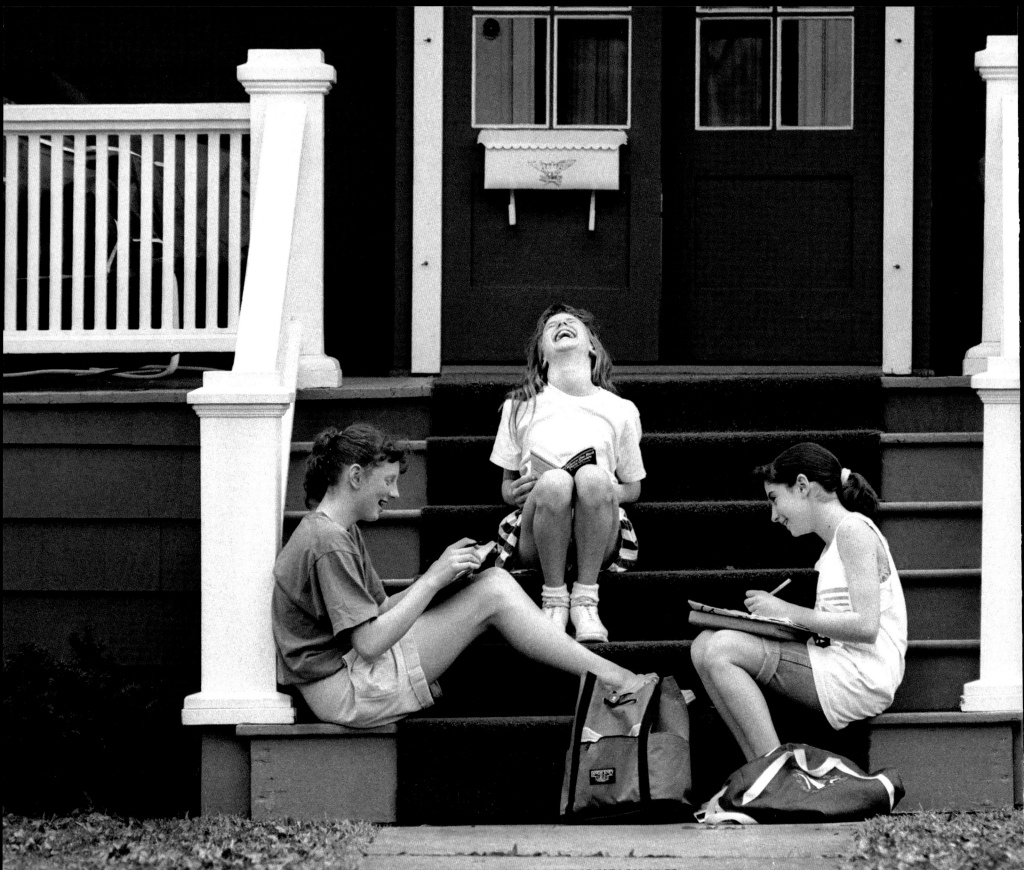

Missing Tooth © 1957 SEPS

I am the middle girl looking into the mouth of another in the 1957 *Post* cover titled *Missing Tooth*. The girl with the missing tooth is Mary Jean Martin, who was in my class. The other girl, on the left, is Eleanor Stevens. Eleanor's dad was the dentist in town, and Eleanor was the sister of Katherine, one of my best friends. I remember that Mr. Rockwell was very particular how I was stooped over for *Missing Tooth*.

—*Betsy Campbell Manning*
neighbor and model for Norman Rockwell

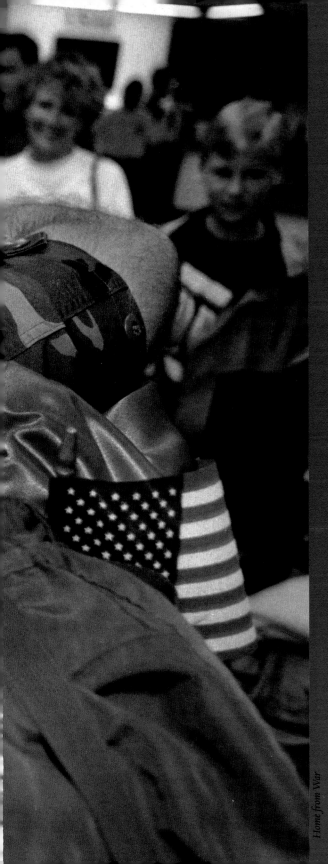

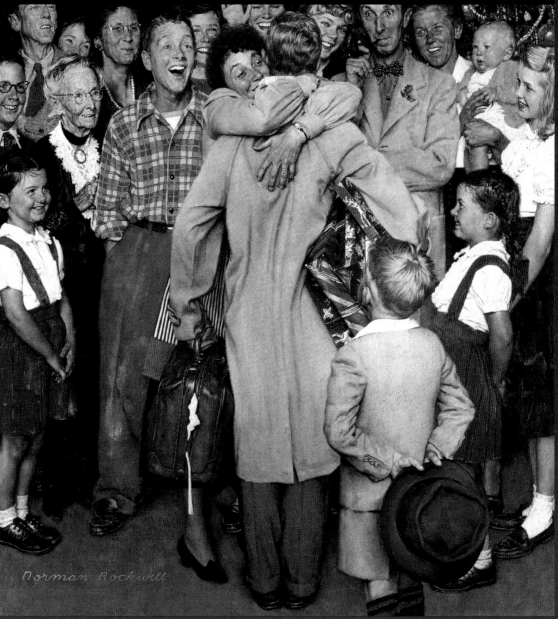

Christmas Homecoming © 1948 SEPS

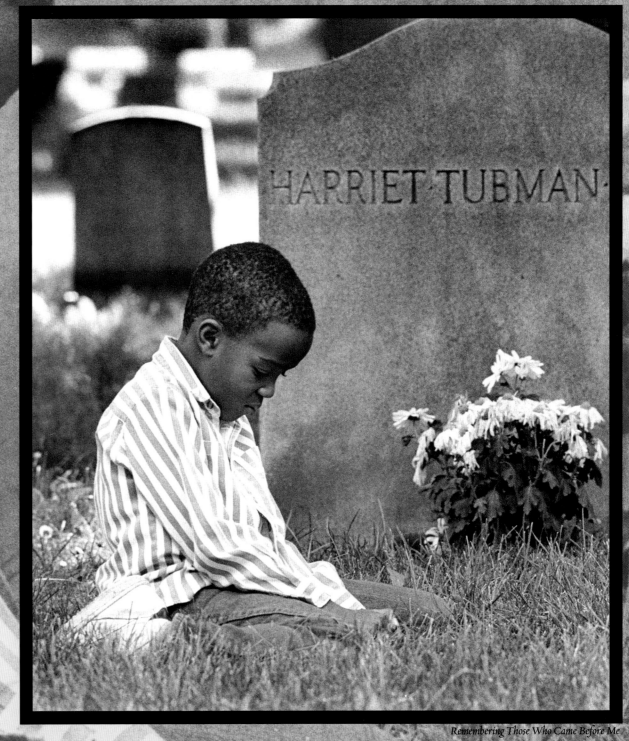

Remembering Those Who Came Before Me

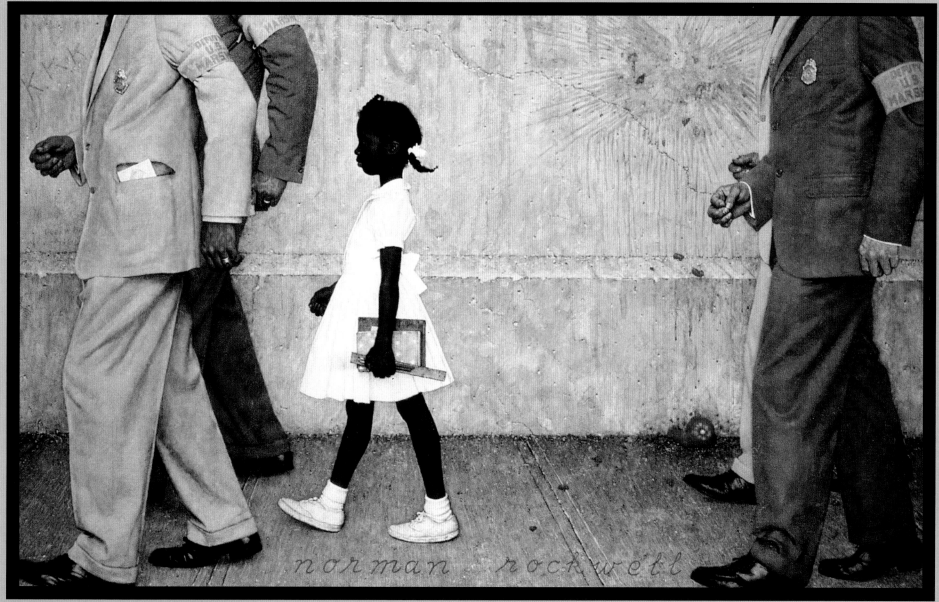

The Problem We All Live With

Most Norman Rockwell paintings show the best side of America: American families enjoying their daily lives—the happy moments of graduation, wedding ceremonies, or a young boy getting his first haircut—things that happen daily in the lives of all Americans. But he also occasionally gave us a glimpse of the ugly side of our society. He wasn't afraid to show us what was happening in America—the good and the bad. His painting *The Problem We All Live With* makes us feel the shame of segregation in America. It shows a young black girl being escorted by guards to an integrated school in the South, when racial segregation was the norm. I think it's a great painting and exemplifies the greatness of Norman Rockwell.

—*Andy Williams*
International recording artist

FOUR FREEDOMS

A working man rises from his seat to make his voice heard at a town meeting. His stance is firm; his grip on the rail before him and the rolled-up agenda in his pocket tell us he has decided he has the same right to address the gathering as the better-off businessmen looking on, their ties still cinched after a day spent at the office. He is of a different class, and yet every bit a member of the same community, and so his words are every bit as important.

People gather in prayer. While we're not let in on the specific event—and its ephemeral casting—the use of light and space by the artist lead us to believe it's a figurative gathering—the message is stark. The participants are of diverse beliefs. The accoutrements of their varied religions tell us as much. Yet they gather as a group, under one roof, with a single aim.

A family has gathered on Thanksgiving Day. The sunny, scrubbed, cherubic faces of family members form an idyllic human frame around the scene: the great fanfare greeting the arrival of the bird, cooked to a perfect golden brown, in the capable hands of the apron-wearing grandmother; the grandfather in suit and tie, standing alongside the matriarch, at a time when we still dressed that way for dinner. The joy of the assemblage is as palpable as the implied message is powerful: this is the land of plenty. This is the domestic American ideal. This is what our boys are fighting for.

And so is this: the scene is an upstairs bedroom in the evening. A father, just north of fighting age himself, clutches a newspaper telling us of the ongoing horrors overseas. His wife lovingly tends to the

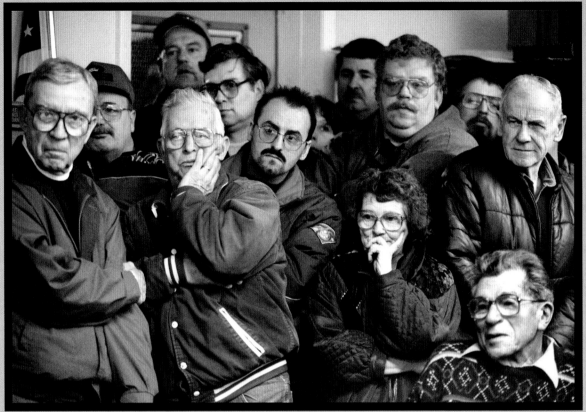

Town Meeting

sleeping children in their shared bed, living emblems of the safety of the American home and way of life. They simply cannot know of the titanic struggle being fought on the beaches of the South Pacific and in the frozen forests of Europe.

The Four Freedoms—freedom of speech, freedom of religion, freedom from want, freedom from fear—were first laid out by President Franklin Delano Roosevelt in his 1941 State of the Union Address. Two years later, they were put to canvas—depicted by Norman Rockwell in four successive issues of *The Saturday Evening Post*.

While the speech that motivated these four works—along with the paintings themselves—would likely reflect a different reality today (Roosevelt's call for worship of the God of our choice, the lack of racially diverse faces at the American Thanksgiving table, and the role of women in the home), the freedoms that Rockwell depicts remain as four fixed stars in our collective national constellation. We debate these freedoms, we protest when we fear they are being diminished, and we send young volunteers half a world away to fight for their preservation.

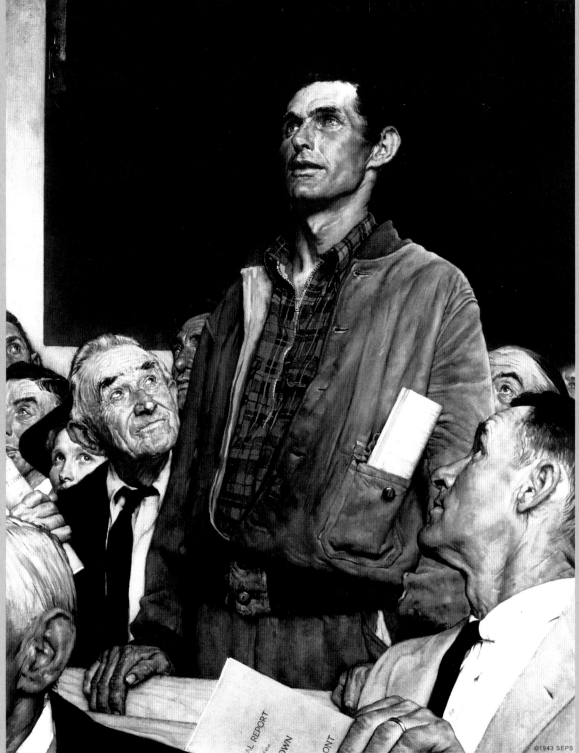

Freedom of Speech © 1943 SEPS

That the foremost visual artist of his time participated in the war bond movement meant the world to the war effort overseas. When the four paintings went on tour, the national campaign raised an estimated $130,000,000 for bombs and bullets and ships and planes. The role of *The Saturday Evening Post* in American life during the 1940s is hard to comprehend in the television and Internet era, but its delivery to millions of American households was a widely anticipated weekly event.

It is difficult today to express or imagine the tactile thrill that the magazine gave its readers, and it started with the covers—during the war years alone, thirty-three of them were the work of Norman Rockwell. It remained on household display for a week at a time, faceup, a coffee table staple in living rooms across the country, where the cover image so often matched the message delivered over the radio by our president—as artful in his use of the spoken word as the great Norman Rockwell was with a brush in his hand.

Effete critics will go on debating Rockwell's art. Others will insist that Rockwell was painting an ideal instead of reflecting a reality. Rockwell himself knew America was all about ideals. He saw his own task through his steady, exacting lens: to remind us who we are, and what we aspire to be. That was . . . and is . . . Rockwell's America.

—*Brian Williams*
Anchor & managing editor
NBC Nightly News

Many people have asked me whether I regard the *Freedom of Worship* and *Freedom of Speech* as great art. I do. Norman himself probably would disagree. He has always modestly labeled himself an illustrator, with no pretensions to fine art. I suspect art critics would say that those two pictures are excellent examples of an illustrator's work at its best, but not great art. I am no art critic, but I still disagree. To me they are great human documents in the form of paint and canvas. A great picture, I think, is one which moves and inspires millions of people. *The Four Freedoms* did—and do.

—*Ben Hibbs*

Editor of The Saturday Evening Post *from 1942 to 1962*

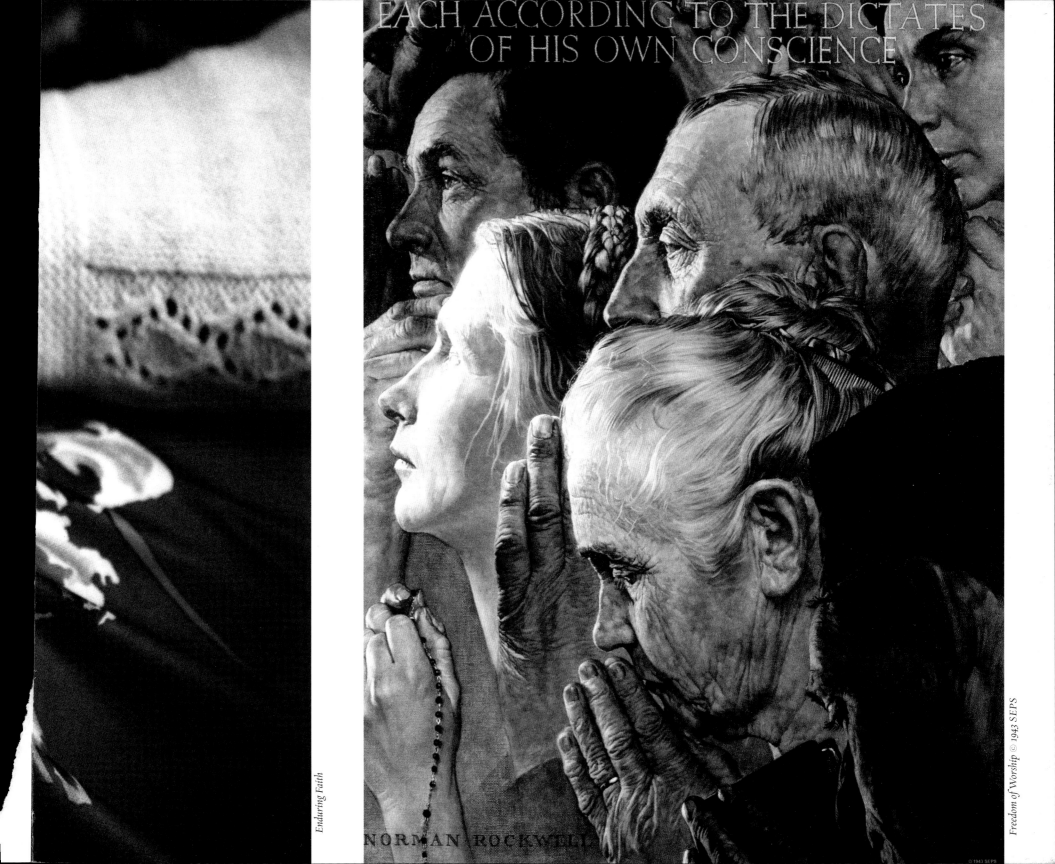

EACH ACCORDING TO THE DICTATES
OF HIS OWN CONSCIENCE

NORMAN ROCKWELL

Enduring Faith

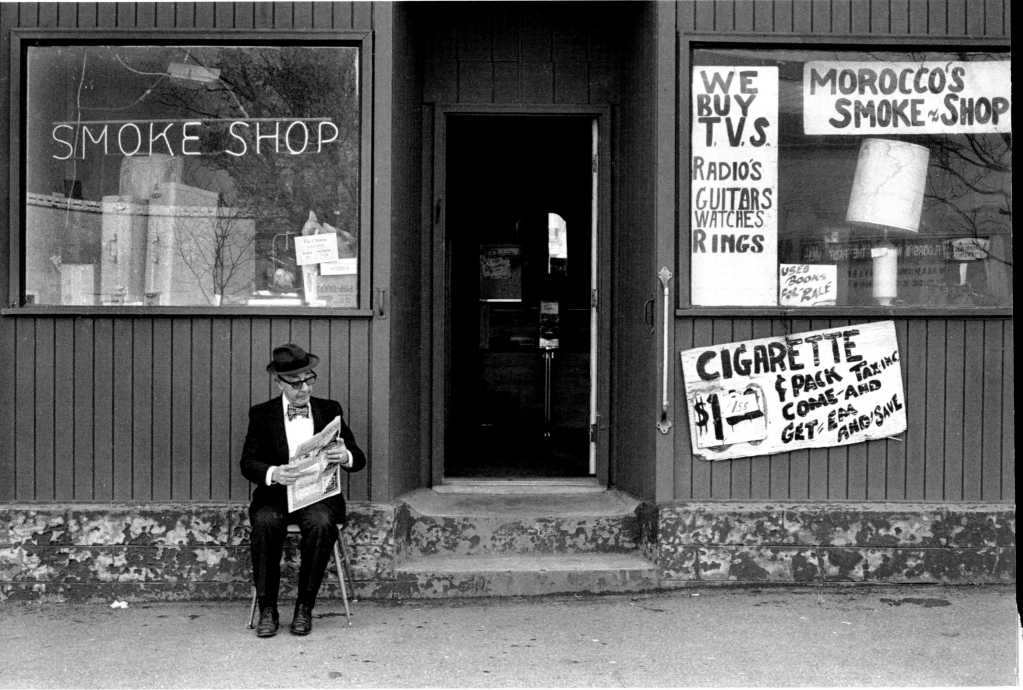

Hometown News

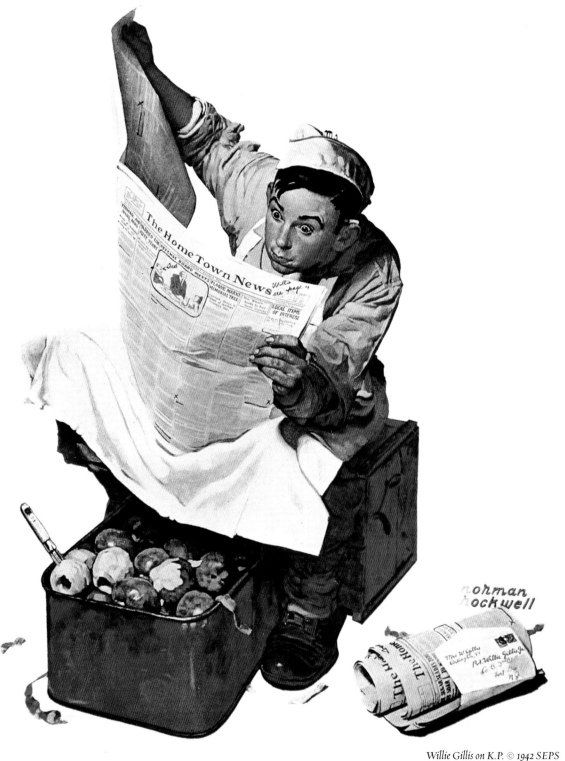

Willie Gillis on K.P. © 1942 SEPS

TELLING A STORY
IN A PICTURE
ISN'T AS SIMPLE
AS IT LOOKS.
IT'S A STRUGGLE,
AT LEAST FOR ME.
THE ORIGINAL IDEA
HAS TO BE REFINED,
PERFECTED.
ALL THE PARTS MUST FIT
TOGETHER,
INTERLOCK.
IF ONE CONTRADICTS
ANOTHER,
THE STORY CRUMBLES.

—Norman Rockwell

I have wonderful memories of my childhood in a small Louisiana town growing up with my parents, a younger sister, and a large group of friends. There were many days filled with baseball, bicycle races, swimming at the local pool, and water skiing at a nearby lake—scenes reminiscent of a Norman Rockwell painting.

I grew up in that environment, and a lot of Rockwell's paintings depict events from my own childhood—my family, friends, and the things we did. They hit home for me, and that's one reason I've always liked them.

I have been a fan of Rockwell's for as long as I can remember, as my parents subscribed to *The Saturday Evening Post*, and as a Boy Scout, I received *Boys' Life* magazine. I always enjoyed the covers. I liked them then, and I like them now.

My wife, Toni, and I collect Rockwell art. We bought our first original work, *Downhill Racer*, in 1972. It's my favorite because I had a go-cart when I was very young, and I raced it in the nearby park. There is also something very familiar about terrifying my little sister with speed.

I think we see ourselves in Rockwell's art, and his work brings back good memories. A lot of his paintings are about the things people remember about their own lives, which is why I think his art is so appealing.

I don't believe that Norman Rockwell's America is just a thing of the past. His paintings still represent America. All anyone has to do is go out and look around. It's definitely still here today, and it's not very far from any one of us.

—A. Emmet Stephenson, Jr.
Businessman, philanthropist, and Rockwell collector

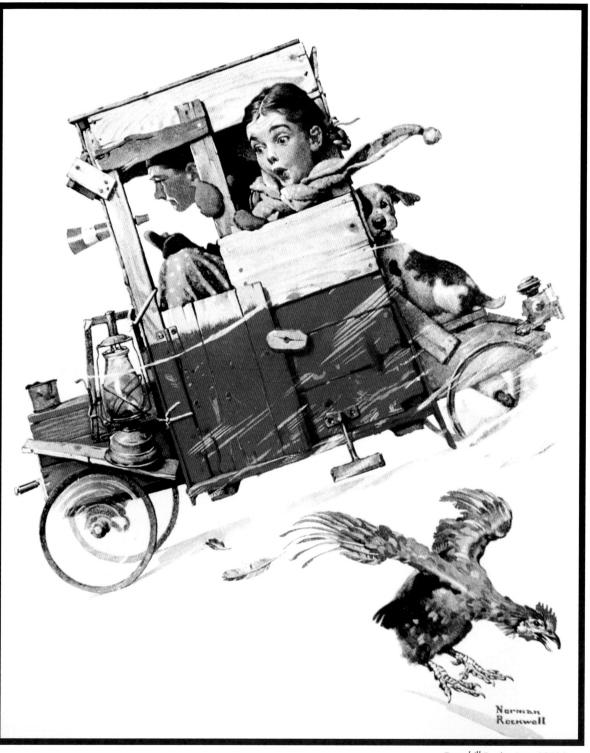

Downhill Daring © 1926 SEPS

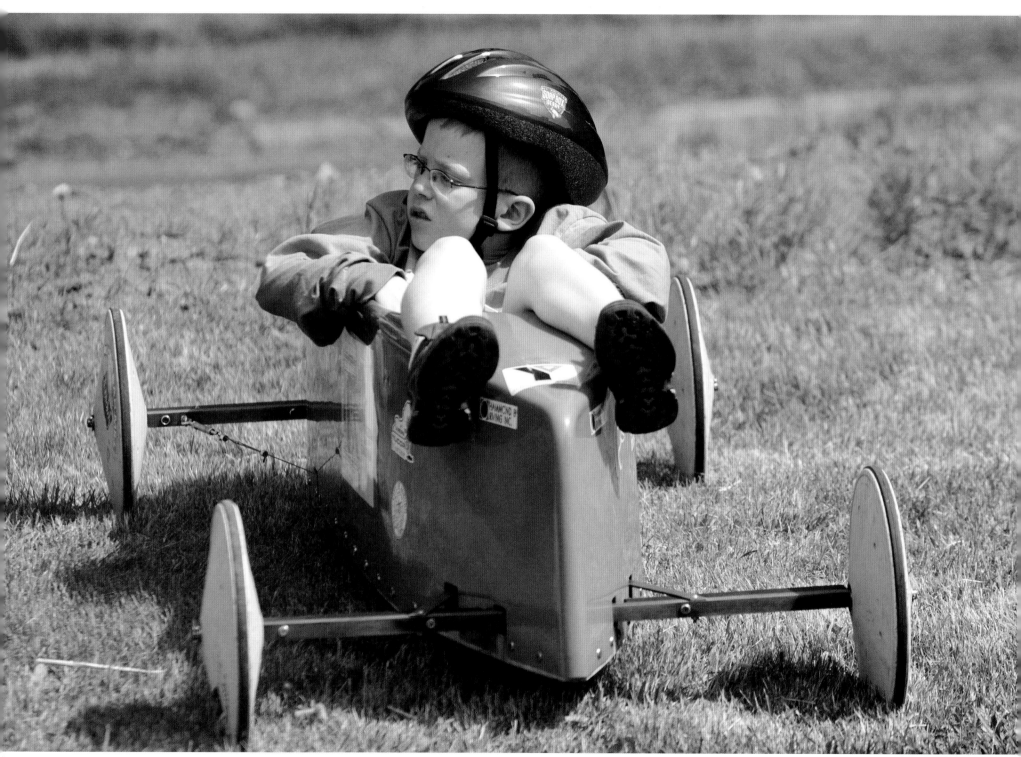

Waiting to Race

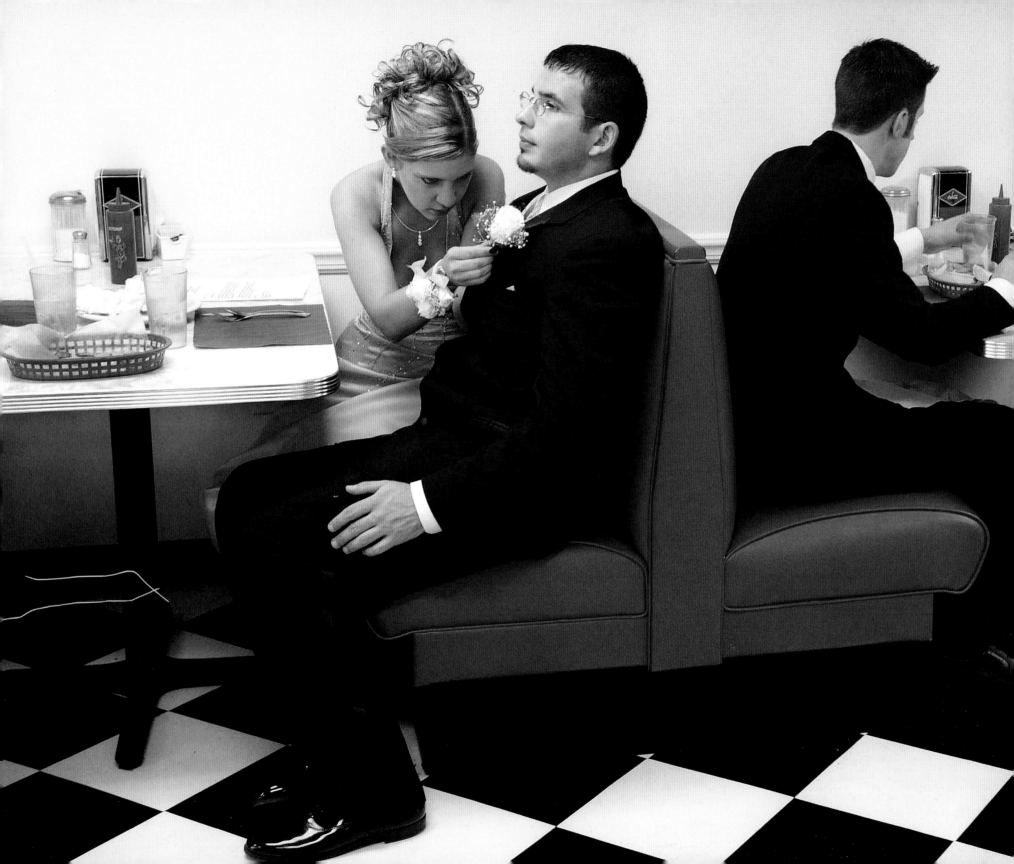

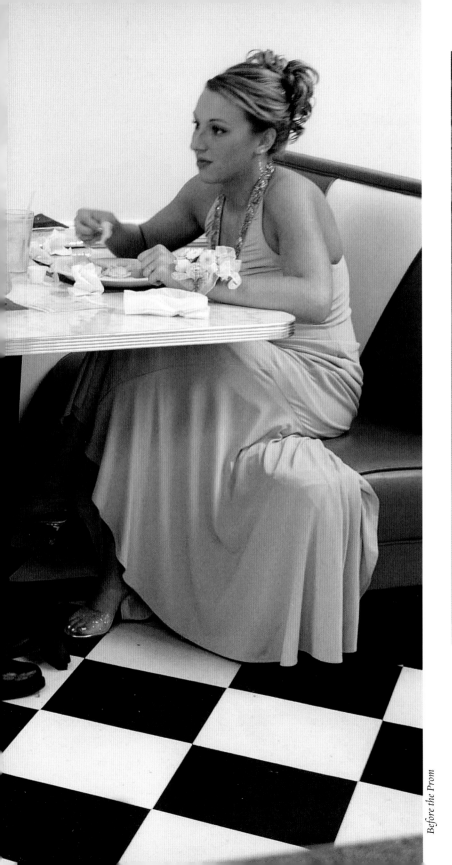

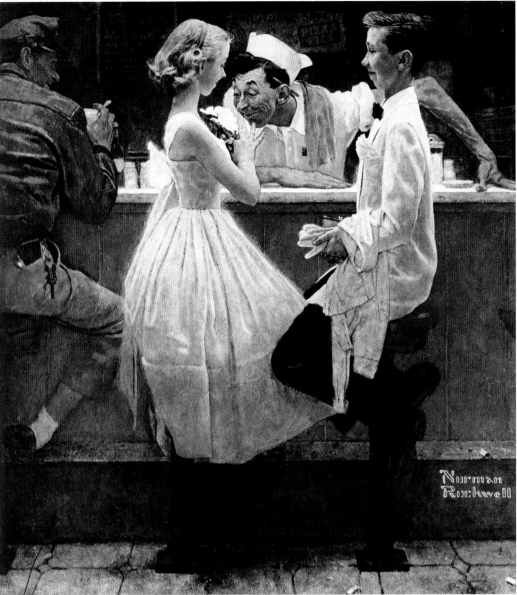

After the Prom © 1957 SEPS

Norman Rockwell has always been a hero of mine. Ever since I was a little girl I've loved his images of American life. His work has touched me deeply, and I'm sure he has been a great influence on the way I paint. We both obviously love our country. Perhaps we paint it a bit kinder and gentler than it actually was, but in my case, and I'm certain in his as well, that is because we take pride in our heritage. I'm only sorry it took the art critics so long to recognize his genius.

—*Jane Wooster Scott*
American artist

The Saturday Evening
POST
June 28, 1958 - 15¢

THE TURNPIKES ARE IN TROUBLE
By HAL BURTON

A VISIT WITH EDDIE ARCARO
By STANLEY FRANK

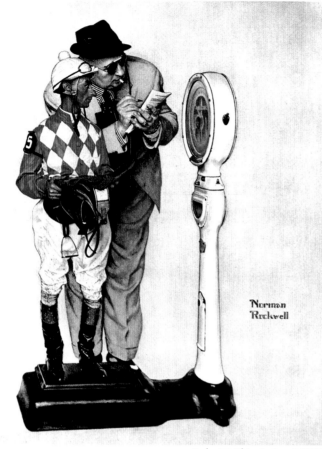

Jockey Weighing In © *1958 SEPS*

It would be almost anti-American for Norman Rockwell's work to be criticized, no matter how subtle the critique was rendered. Rockwell's work has become a symbol of all that's good in America, and we defend it vehemently. It is not only the America we wish it to be, but the America it is. Norman Rockwell's name should be enshrined as "the artist who rendered back to Americans the image they wished to see."

—*Edward Asner*
Emmy award-winning actor

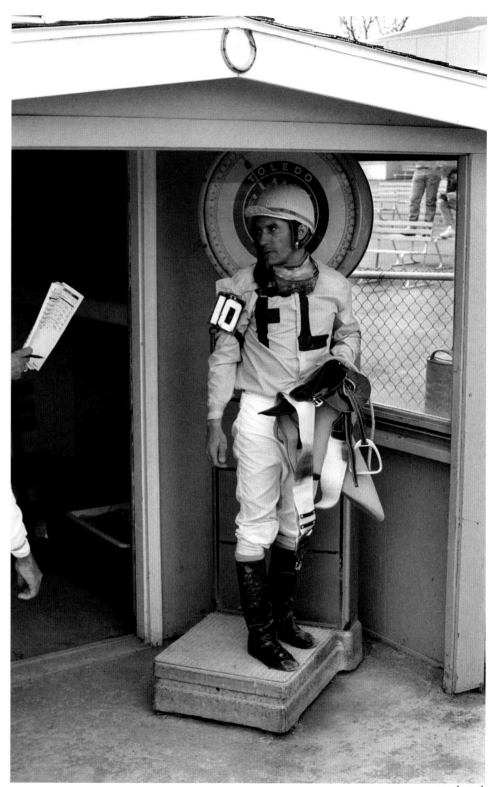

On the Scale

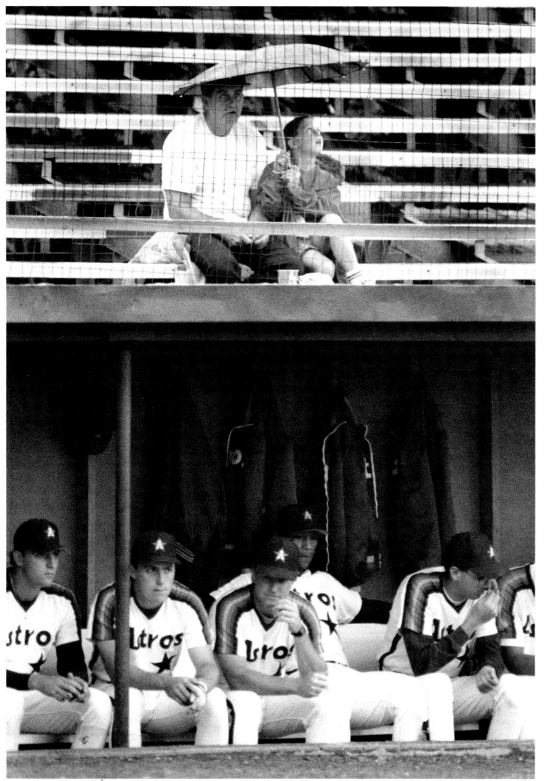

Rain Delay

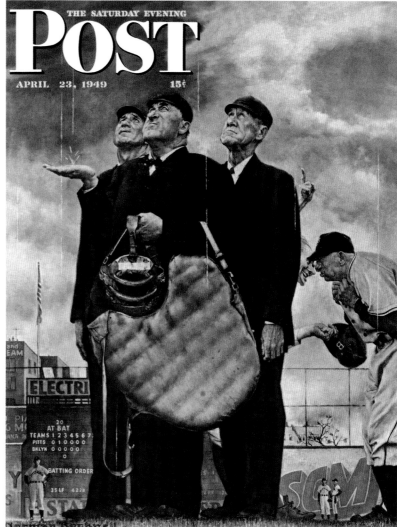

RIGHT FROM THE BEGINNING,
I ALWAYS STRIVED TO CAPTURE
EVERYTHING I SAW AS
COMPLETELY AS POSSIBLE.

—*Norman Rockwell*

I remember when I was growing up how we'd look forward to every Saturday and the arrival of the *Post*. We were always excited to see what Rockwell had on the cover because his work was always so inspirational.

At that time, the *Post* cost a nickel. I was born in 1940 and grew up in Oklahoma in a family of six. I remember my childhood and what was happening in our country. You can't tell me that what he painted didn't happen because I know it did. I remember wartime and the rationing, and the fact that we couldn't have bubble gum. I remember the Rockwell pieces about sons going off to war and the excitement of their return.

And it isn't just his serious works that reflected life. Think of the piece *Looking Out to Sea*, with a grandfather and grandson looking out across the ocean. You could probably drive to Maine or Massachusetts and see that happening. Or the image he did of the three boys fishing at the fishing hole. I had three sons and we lived on a river. I'd see that happen in my yard throughout the 1970s and 80s as my boys grew up.

To me Rockwell painted humanity—he painted mankind and what was going on. To me, Rockwell painted life.

—*Jane Burns*
Director, the Midwest Museum of American Art

Fishing with Dad

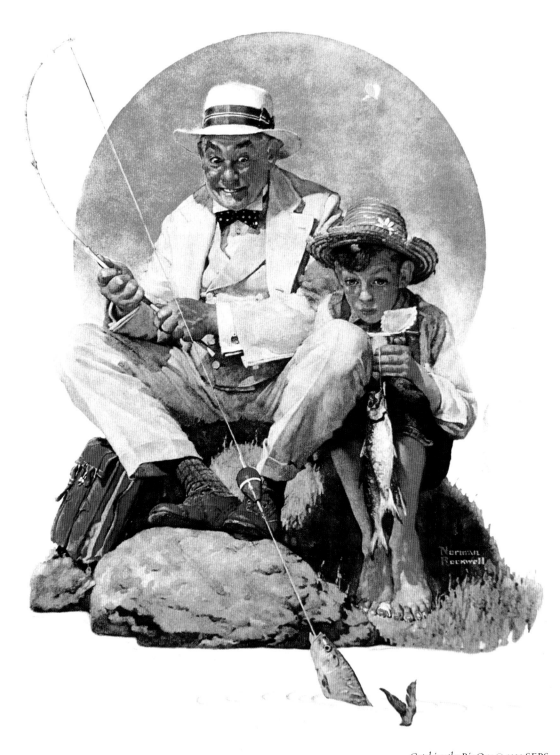

Catching the Big One © 1929 SEPS

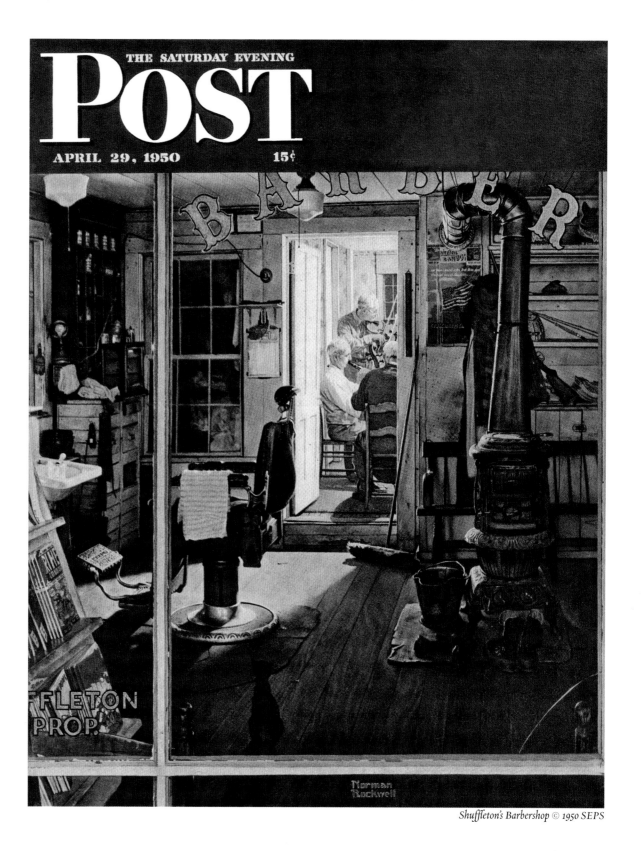

Norman Rockwell captured moments in memories of pleasure and pain, past and present, growing up in and living the American Dream. The magic seen in every "Norman Rockwell" was his ability to bring life to a broomstick or a pair of overalls.

He activated our senses, making us all place ourselves in his creation of art.

—*Duane Allen*
Oak Ridge Boys

Shuffleton's Barbershop © 1950 SEPS

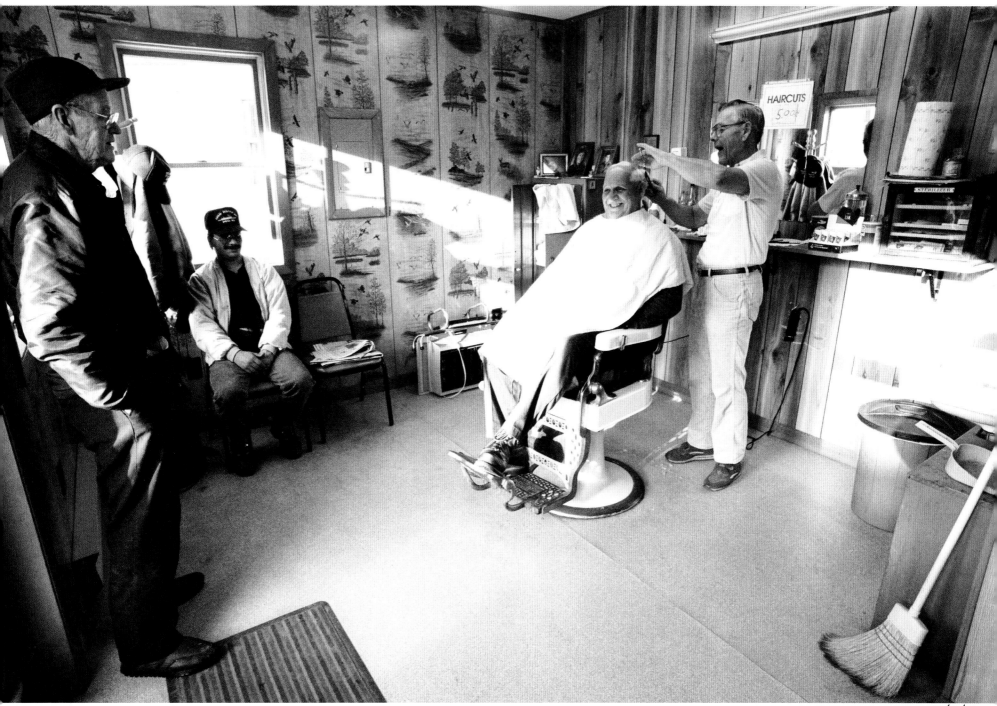

Barbershop

EARLY IN MY CAREER
I DISCOVERED THAT FUNNY IDEAS,
PURE GAGS, WERE GOOD,
YES, BUT FUNNY IDEAS
WITH PATHOS WERE BETTER.
NOT ONLY PATHOS, THOUGH;
JUST SOMETHING DEEPER.
AN IDEA WHICH IS ONLY
HUMOROUS DOESN'T STAY
WITH PEOPLE, BUT IF
THE SITUATION DEPICTED
HAS SOME OVERTONES OR
UNDERTONES, SOMETHING
BEYOND HUMOR, IT STICKS
WITH PEOPLE AND THEY LIKE IT
THAT MUCH MORE.

—*Norman Rockwell*

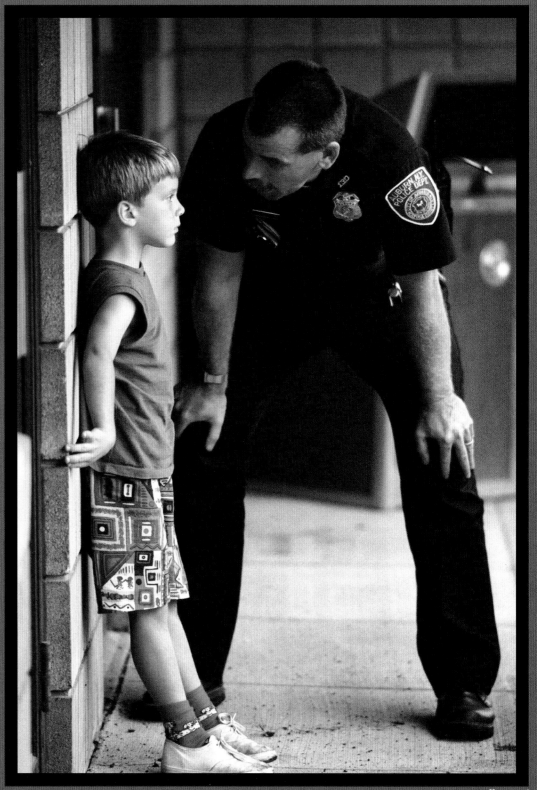

Officer Lumb

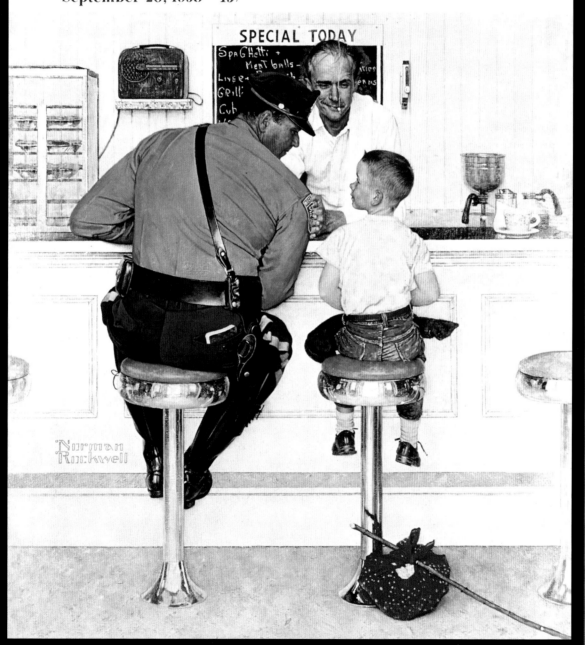

The Saturday Evening

POST

September 20, 1958 — 15¢

Mickey Cohen:
The Private Life of a Hood

By Dean Jennings

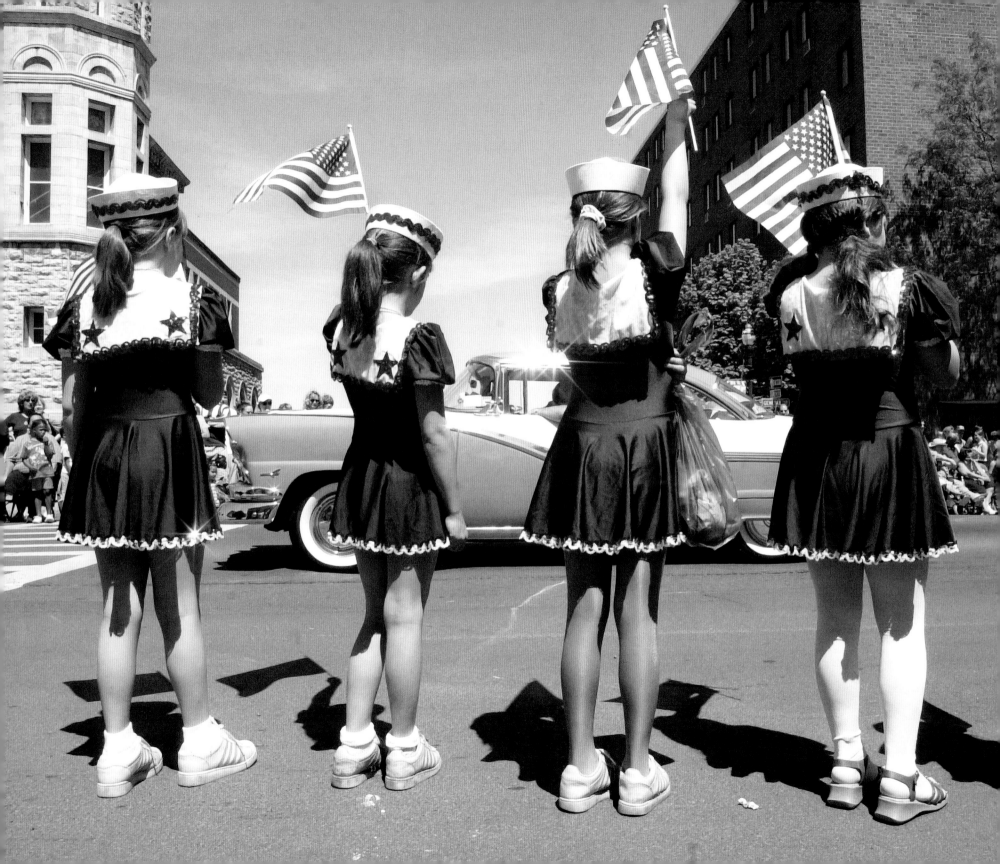

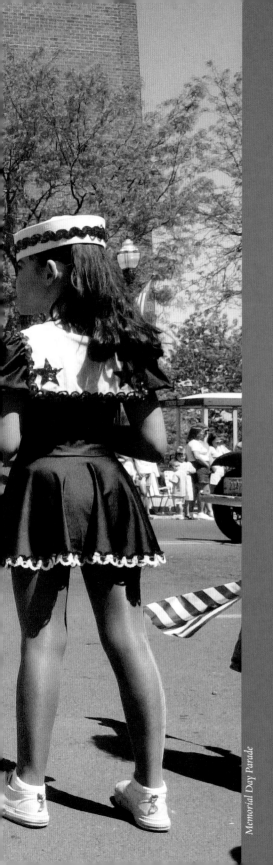

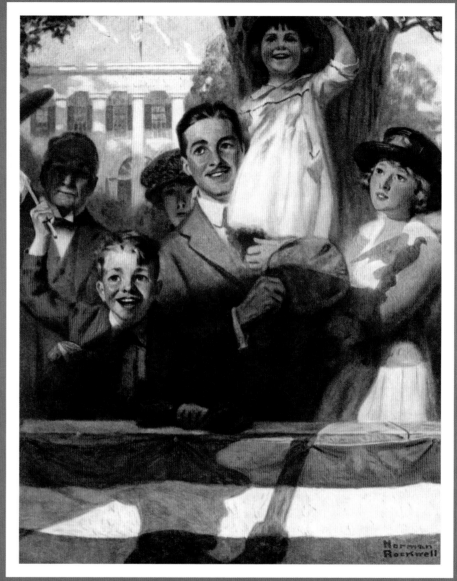

Spectators at the Parade

WITHOUT THINKING TOO MUCH ABOUT IT IN SPECIFIC TERMS,
I WAS SHOWING THE AMERICA I KNEW AND OBSERVED
TO OTHERS WHO MIGHT NOT HAVE NOTICED.
MY FUNDAMENTAL PURPOSE IS TO INTERPRET
THE TYPICAL AMERICAN. I AM A STORYTELLER.

—*Norman Rockwell*

I got interested in art because it was all around me. It was so much a part of our lives that I thought every kid had a Rockwell hanging over their table. For me, I loved the way Rockwell painted kids and animals. He was a master of detail and could capture their moods in such a way that you could see it in their eyes. He was amazing. My mom fell in love with art and soon my parents were collecting the artists that critics wanted to stay away from—especially the illustrators. I remember people chuckling when my parents bought Rockwells, but they didn't care because they loved his work. When my parents purchased his pieces, they'd contact Rockwell to get more specifics on it—like who it was done for and why. My parents would call, and if he wasn't there, he'd always call back. If my mom sent him a letter, Mr. Rockwell would write back to Mom and always draw little pictures of a dog on it. The dog would always be chasing a fly or in some kind of predicament. And my mom made sure we all had copies of Norman Rockwell's book, *Willie Was Different*, signed to each of us.

My parents sent Rockwell an unsigned portrait they purchased by another American artist who Rockwell considered a mentor. The charcoal sketch of Rockwell smoking his pipe was returned to the family signed by Rockwell, with a note that read: "This sketch of me was made by Dean Cornwell, my good friend who I admired greatly."

Once while traveling through Vermont, I decided to re-create one of the famous Rockwell pictures. We were on the White River, at the very bridge where the swimming hole was painted. I thought I'd reenact the jump in the swimming pond scene, but my two older brothers were smart enough not to join in. Apparently my brothers and Dad knew exactly what was going to happen. Even though it was about ninety degrees that day, the water was only about forty degrees.

Our passion soon became a business, but first and foremost it was something we loved to do. My brothers and I grew up around art and were all influenced by it personally and professionally. And I think I can speak for all of us when I say that we think Norman Rockwell was the most important artist of the twentieth century. He was one of the nicest guys I've ever talked to and such an incredibly gifted artist. He was a super human being who believed in America and projected that in his art. What you saw in his paintings was what he was. He was as real as they come and a very humble guy.

—*Peter Rainone*

A professional musician and art collector, Rainone is the son of the late Dr. Carl Rainone and his wife, Cherry, both lovers of American art—especially the art of Norman Rockwell. Rainone said the family has a book that Rockwell signed "To Carl and Cherry Rainone, My Texas Friends."

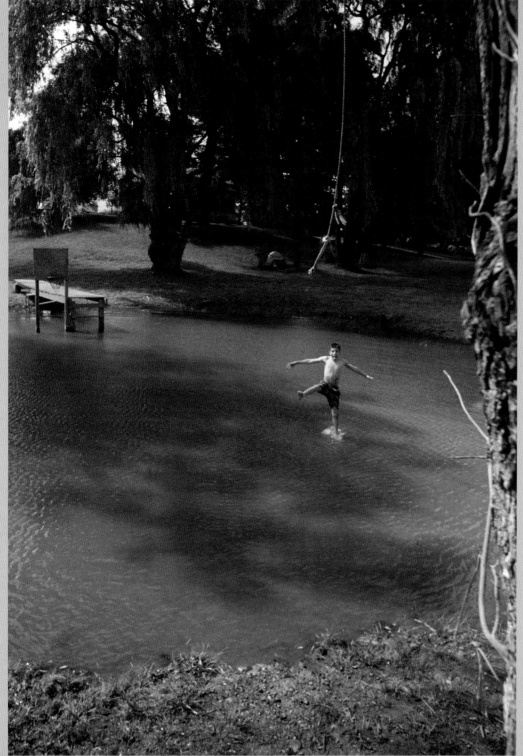

Swimming Hole

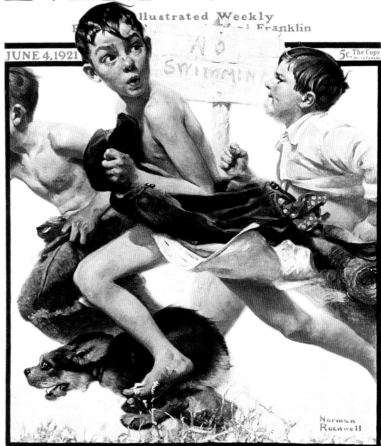

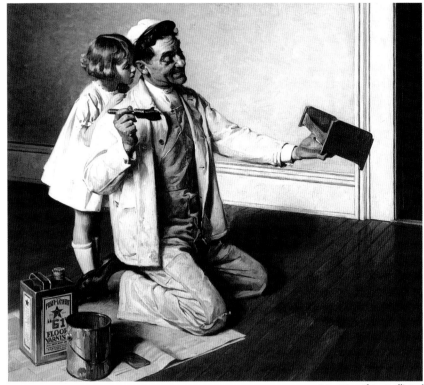

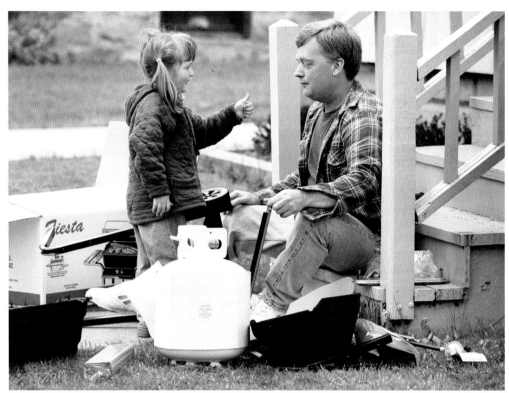

Man Varnishing Doll's Bed

Thumbs Up

Some might try to argue that there is no such thing as a Norman Rockwell family. Many wonder how we can celebrate happy moments when problems like poverty, divorce, and lack of health insurance are the frequent topics of the evening news. I would suggest that there is room for hearing about all of it; and while it's important to be informed, it's just as important to be inspired.

It's inspiration that I find in Norman Rockwell's paintings and Kevin Rivoli's photographs. Through their art work, we are given moments of hope and happiness that are just as real and perhaps more prevalent than the distressing stuff we see on the news.

The Rockwell paintings give us a place to simply be. To be in the moment of a child's baseball game, a boy with endless love for his puppy, or a first love. These are the moments that make life valuable.

While some watch the evening news and are challenged to make the world better, others become discouraged and ask, "Why bother?"

That's why we need the Norman Rockwells and Kevin Rivolis of this world. To capture and celebrate those "What's Possible!" moments. That's what gives the inspired the moments to create and strive for.

— *Daryn Kagan*

Creator and host of DarynKagan.com, the web's inspirational news destination, and author, What's Possible! 50 True Stories of People Who Dared to Dream They Could Make a Difference

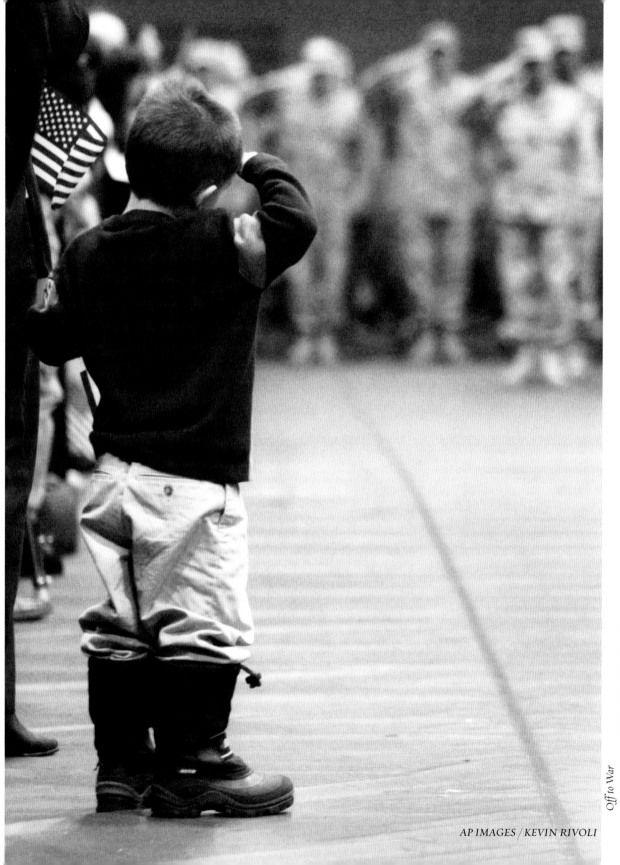

AP IMAGES / KEVIN RIVOLI

Off to War

I grew up loving Norman Rockwell's art. As I grew older, I began to appreciate more and more how he immortalized the simple things in life that mean so much to all of us, as well as some of the major changes that were about to happen in our world. He captured our great moments and simple pleasures for all time.

— *Dick Clark*
Emmy award-winning television and radio personality

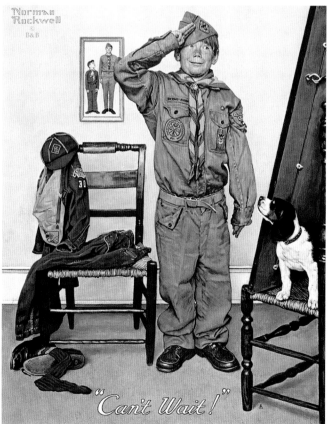

Can't Wait! © *Brown & Bigelow, Inc., St. Paul, Minnesota*

My painting, *The Golfer*, captures an expression and feeling that anyone who has played the game has experienced. That is Rockwell's secret: we can relate to the image and story he paints with our own experiences.

—*Rich Berg*
CEO of Performance Trust Capital Partners
and collector of Rockwell artwork

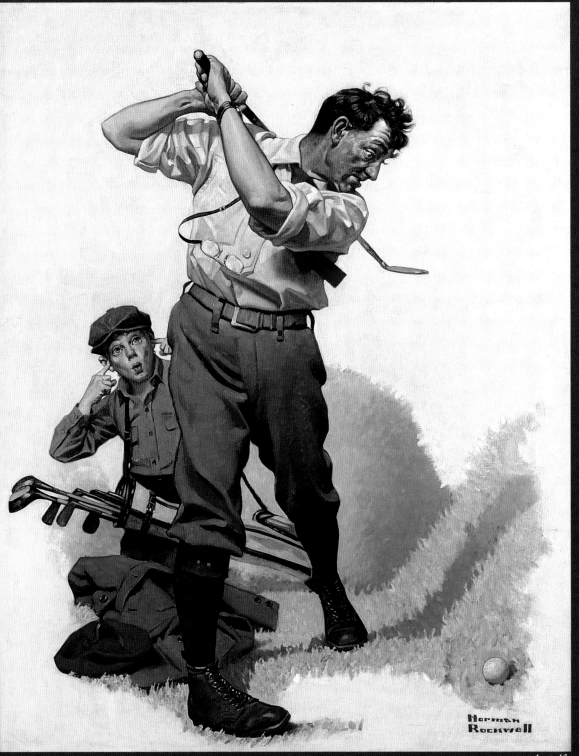

The Golfer

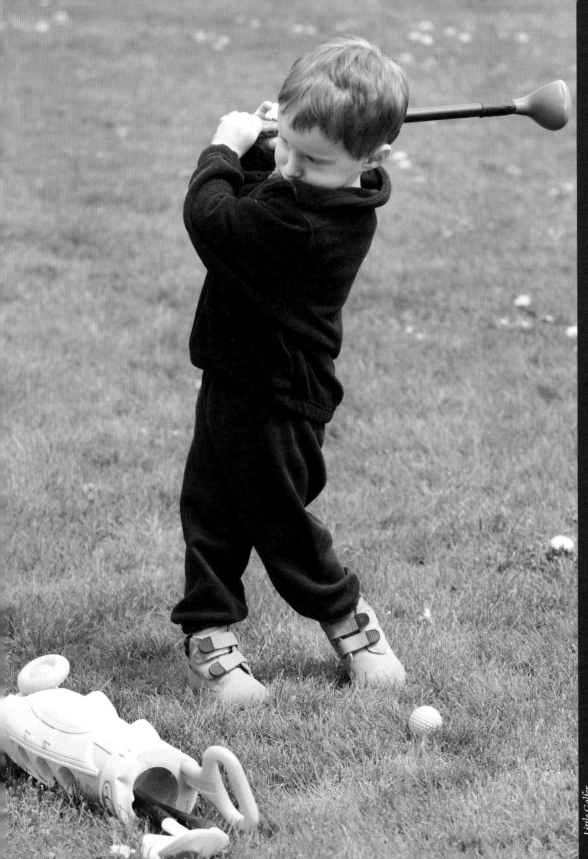

Little Golfer

One of my most memorable trips came in 1972 when I flew to Stockbridge, Massachusetts, and sat for Norman Rockwell for the portrait painting that is one of my most treasured possessions today.

To so many of us, the paintings of Norman Rockwell told the story of everyday America as nobody else ever has. This combination of Rockwell's paintings and Kevin Rivoli's photographs make a striking chronicle of Americana.

—Arnold Palmer
Internationally known golf legend

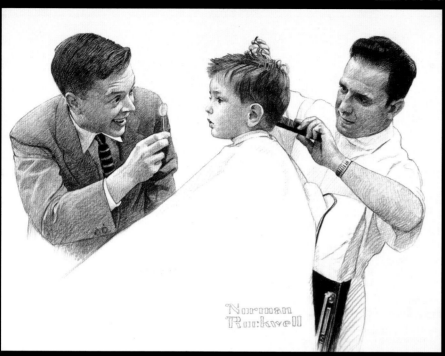

First Haircut

The commonplaces of America are to me the richest subjects in art. Boys batting flies on vacant lots; little girls playing jacks on the front steps; old me plodding home at twilight, umbrella in hand—all of these things arouse feeling in me.

—Norman Rockwell

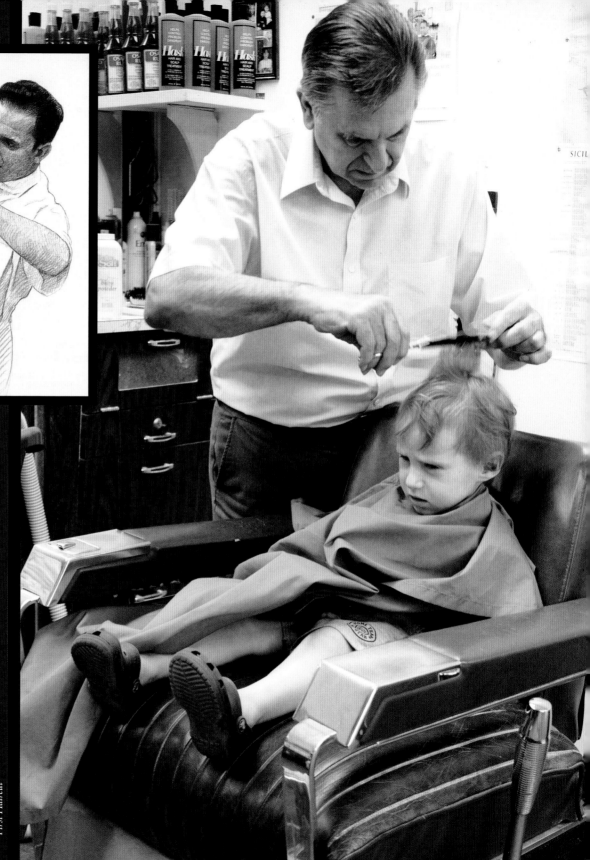

First Haircut

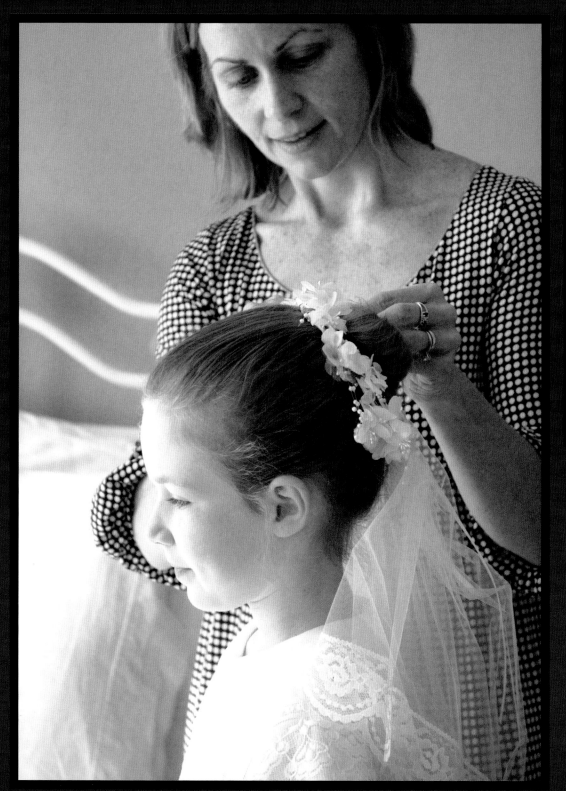

New Hat

First Communion

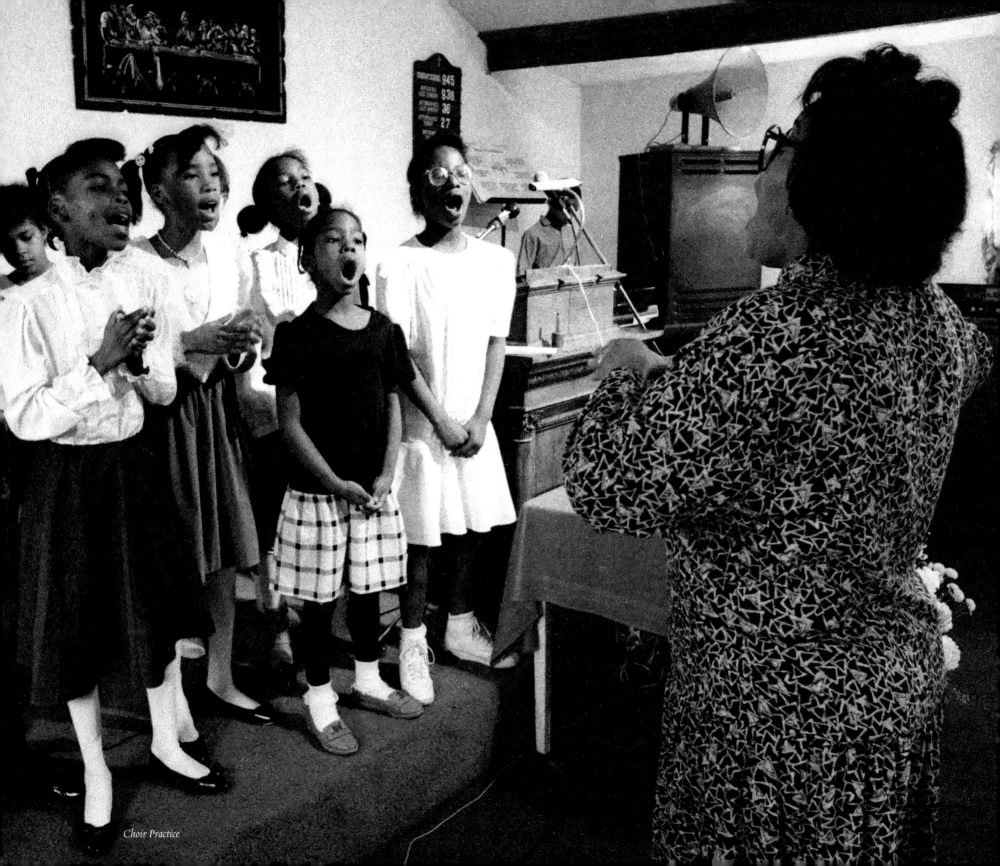

Choir Practice

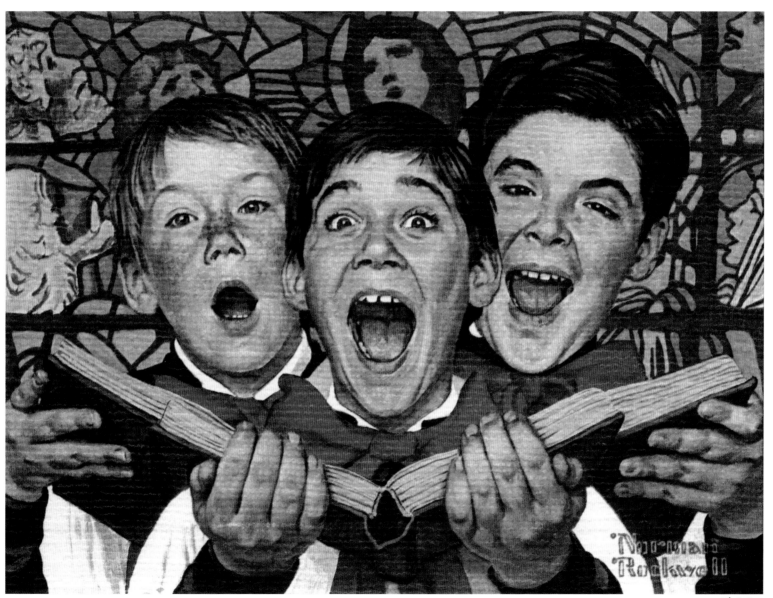

Choir Boys

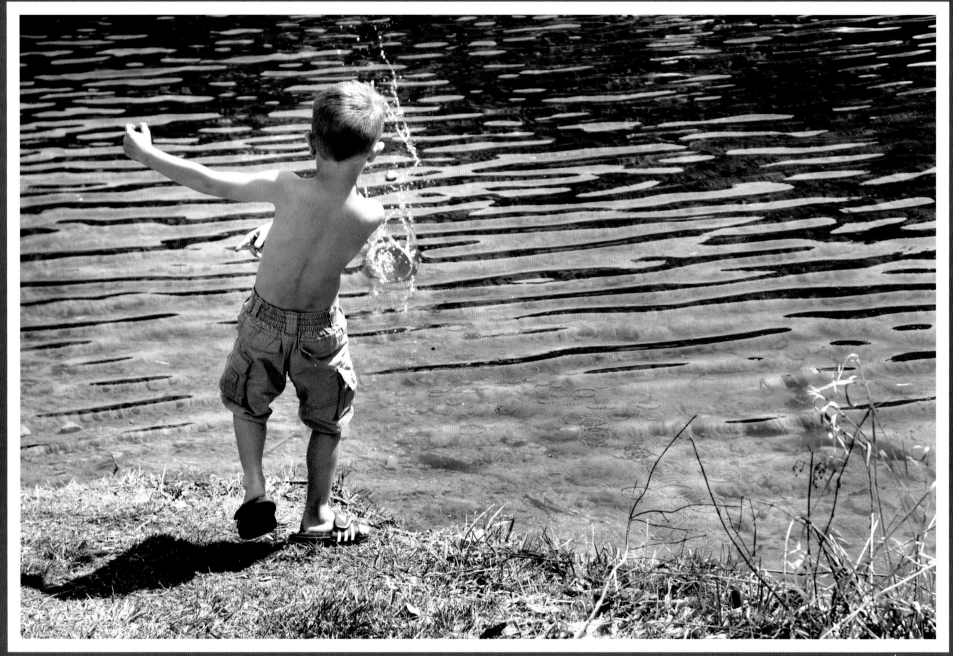

Skipping Stones

IF WE LOSE WHAT IT IS THAT ROCKWELL'S ART STOOD FOR,
THEN WE HAVE LOST SOMETHING VERY BASIC
TO WHAT IT MEANS TO BE AN AMERICAN.

— *Robert A.M. Stern*

Dean of the Yale School of Architecture, founder and senior partner of Robert A.M. Stern Architects

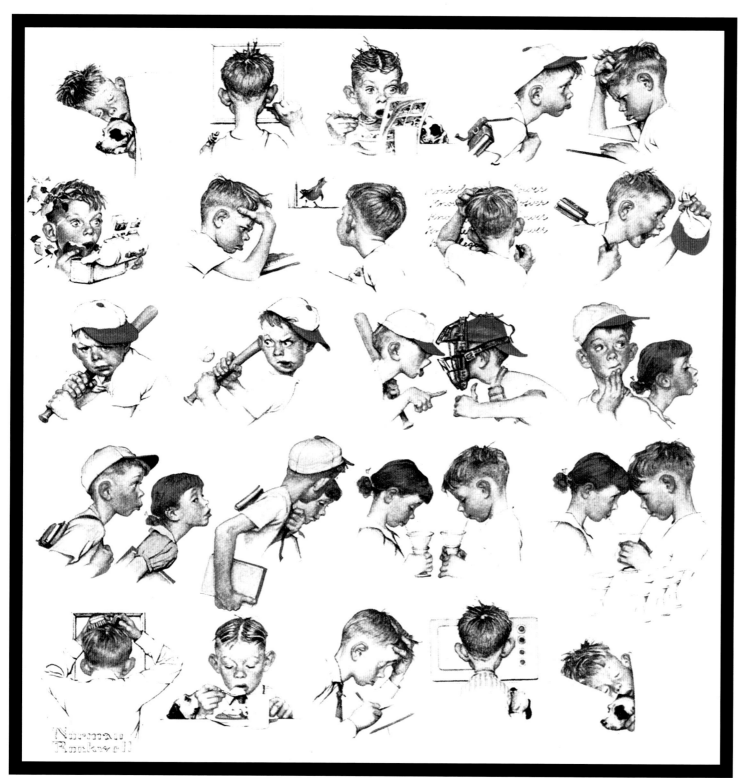

Day in the Life of a Boy © 1952 SEPS

Norman Rockwell—just saying the name makes me smile. My family eagerly awaited his next cover on *The Saturday Evening Post*, fully expecting to be delighted, and we were, without exception. I've always loved his work. It was so full of tenderness, humor, joy, sweetness, and heart. Contrary to the view that he created an idealized America, Mr. Rockwell captured and shared a profoundly authentic expression of the fun of living in the moment—which is within everyone's reach. He revealed how we were, how we still are, how we'll always be, because we are human beings. He's one for the ages, a "be here now" guy, and a great and loving artist. I love you, Norman Rockwell, and I thank you so much. And thank you, Kevin Rivoli, with your talent, skill, and magic lens, for proving my point.

—*Valerie Harper*
Emmy award-winning actress

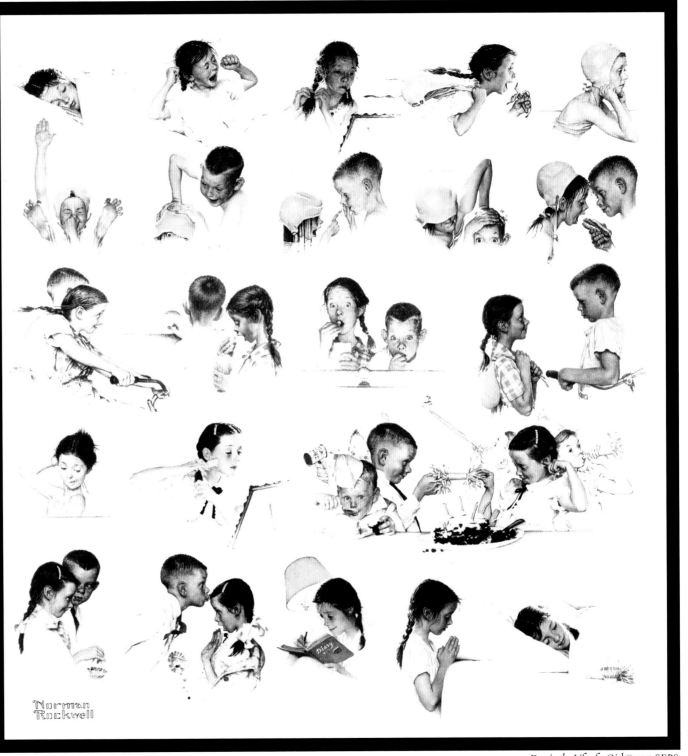

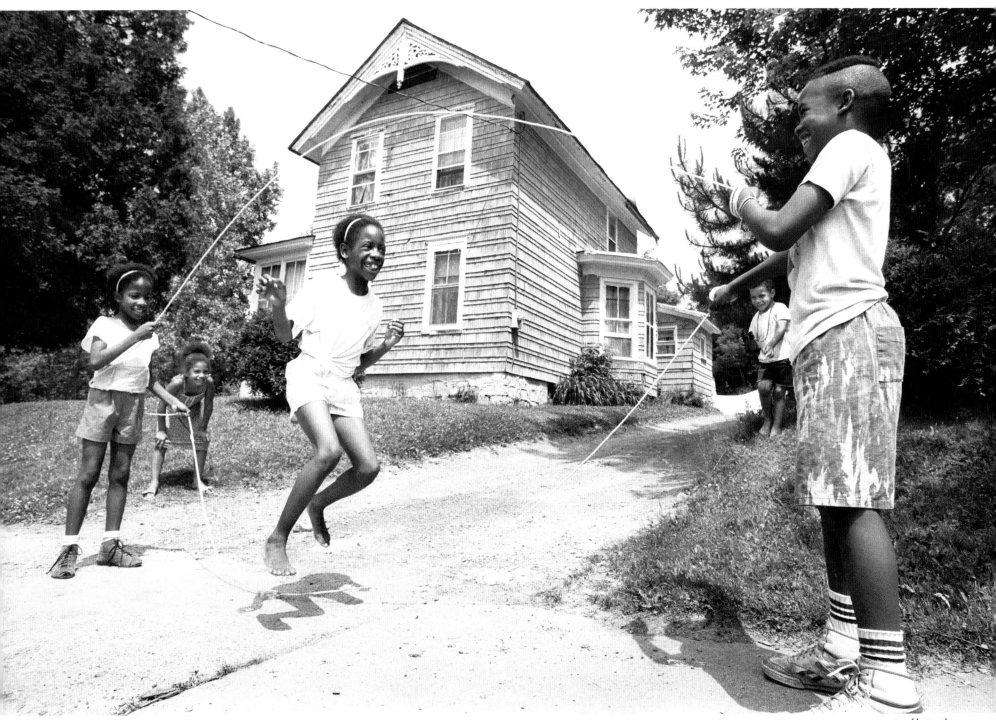

Double Dutch

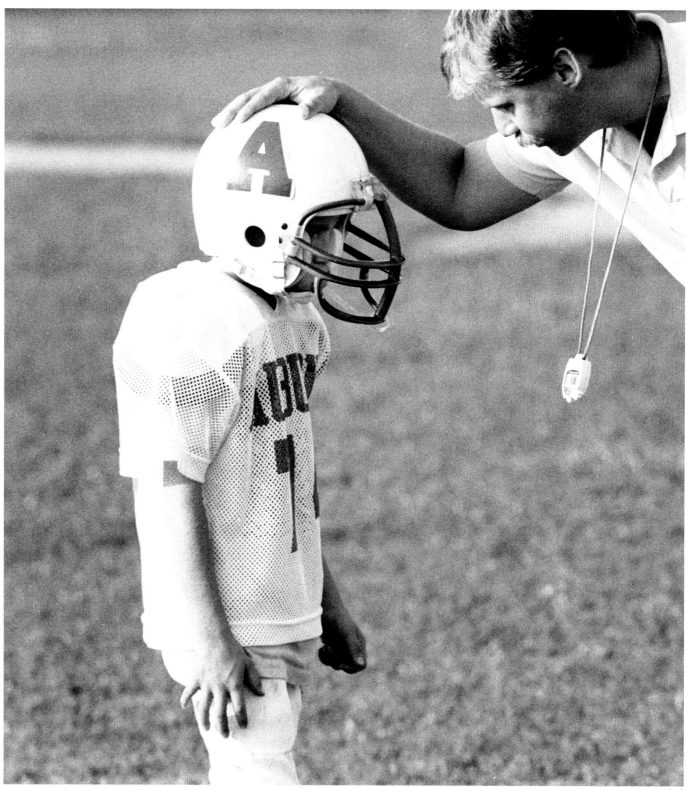

Good Job

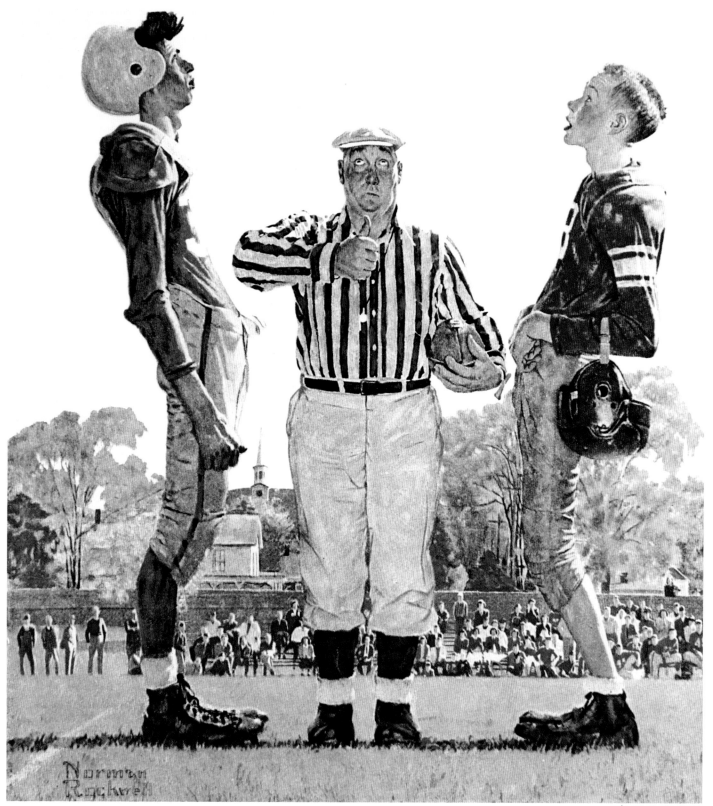

The Toss © 1950 SEPS

In *The Toss,* Norman Rockwell captures, as only he could, the innocence and excitement of a game about to begin. You can feel the butterflies in the stomachs of the young boys as they anxiously watch the coin that will determine who will go first in the pending contest. He captured the pureness of sport, the excitement of that chance to step up on a field and test yourself against your peers.

You can see the yellow leaves of fall and almost feel the crisp air as the coin hangs suspended.

It is the beginning of a physical battle, and in that moment before the coin falls there is held all the potential and promise of victory for both boys.

—*Jerry Jones*
Owner, the Dallas Cowboys

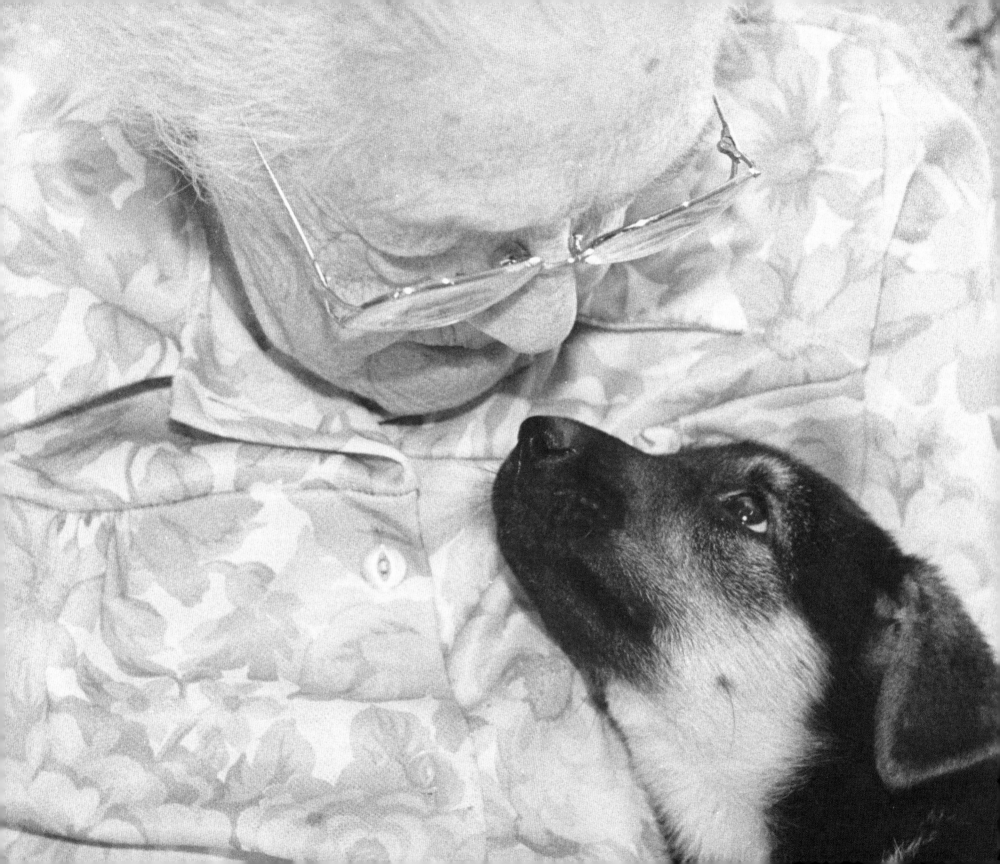

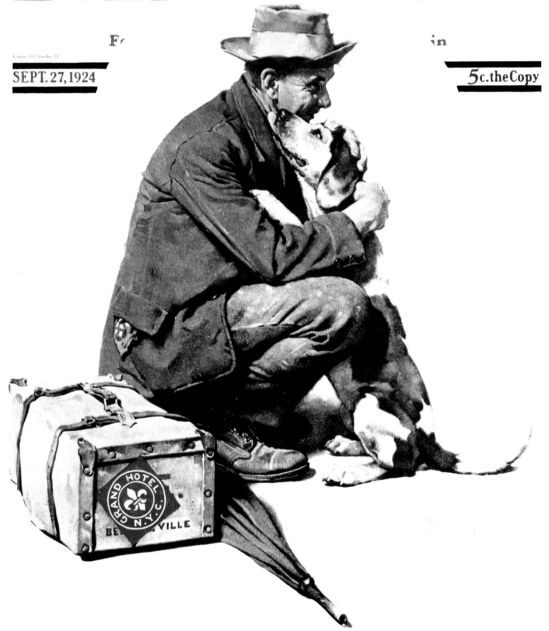

THE SATURDAY EVENING POST

Volume 197, Number 13

SEPT. 27, 1924

F... ...in

5c. the Copy

Former Speaker Joseph G. Cannon — Lucy Stone Terrill — Courtney Ryley Cooper
P. G. Wodehouse — Octavus Roy Cohen — Will Payne — Stephen Morehouse Avery

Pals © *1924 SEPS*

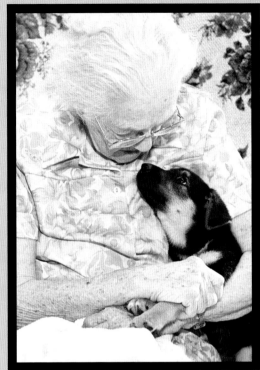

Puppy Love

Readers will wonder how Norman Rockwell was able to capture so much of what makes life special and put it in his paintings. Rockwell's art transcends generations. Both young and old can imagine and relate to the joy, contentment, humility, mischievousness and the many other aspects of life . . . the way we want it to be.

Kevin Rivoli has been able to capture these same Americana images with his artistic photography.

—Joan SerVaas

President & CEO

Curtis Publishing Company

The Saturday Evening Post

TO ME, NORMAN ROCKWELL
IS ONE OF THE GREATEST
PAINTERS IN THE WORLD.
—*Tony Bennett*
Grammy award winning singer and artist

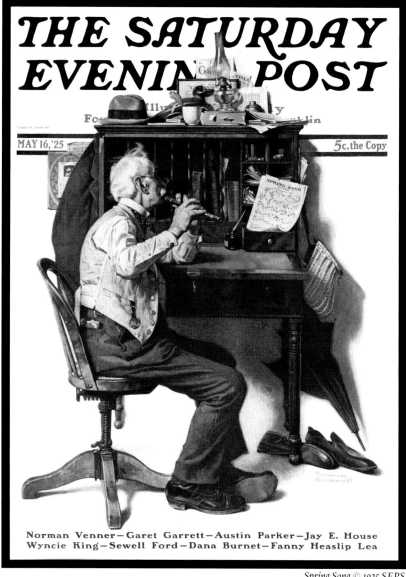

Spring Song © *1925 SEPS*

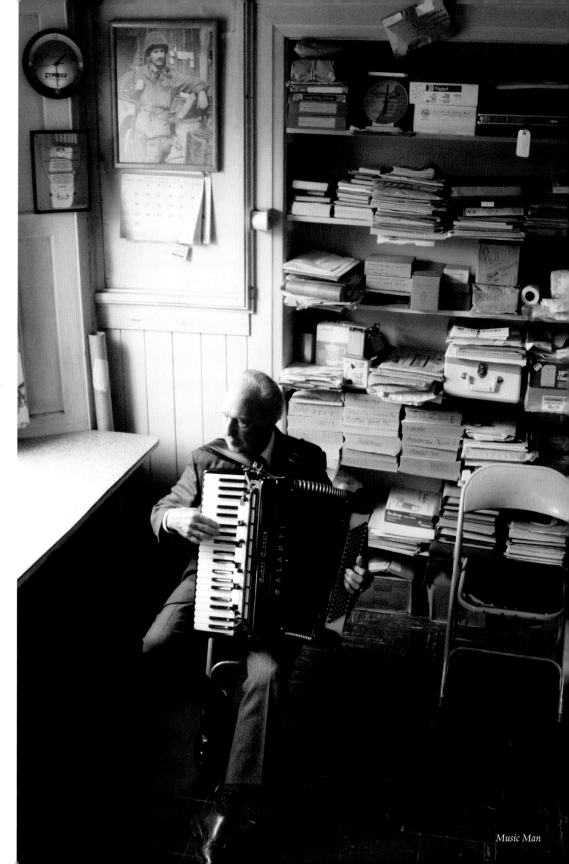

Music Man

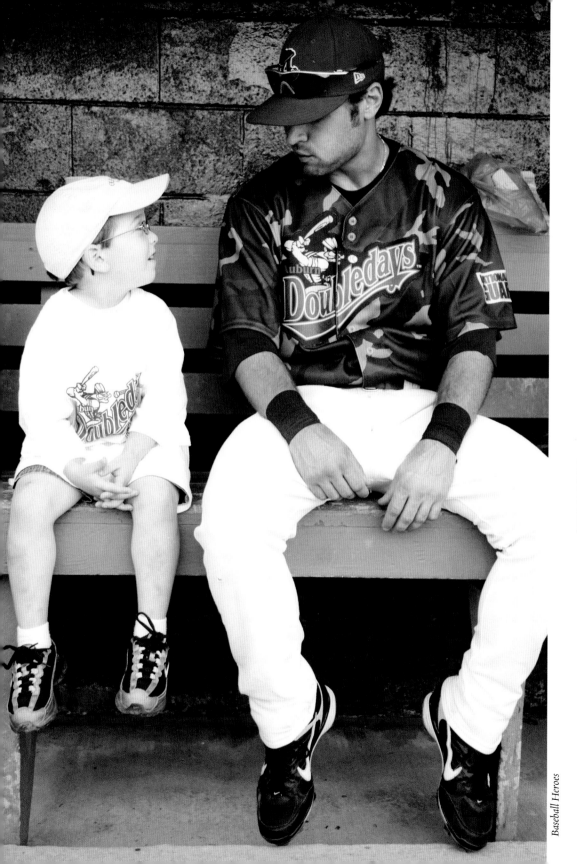

BEGINNING
ESCAPE
A NOVEL OF TODAY'S REIGN OF TERROR

100th Anniversary of Baseball © *1939 SEPS*

I was only one of the millions of people who looked forward to Norman Rockwell's creations on the cover of *The Saturday Evening Post* every week. He was an innovator and a true genius.

—*Jack LaLanne*
Godfather of fitness

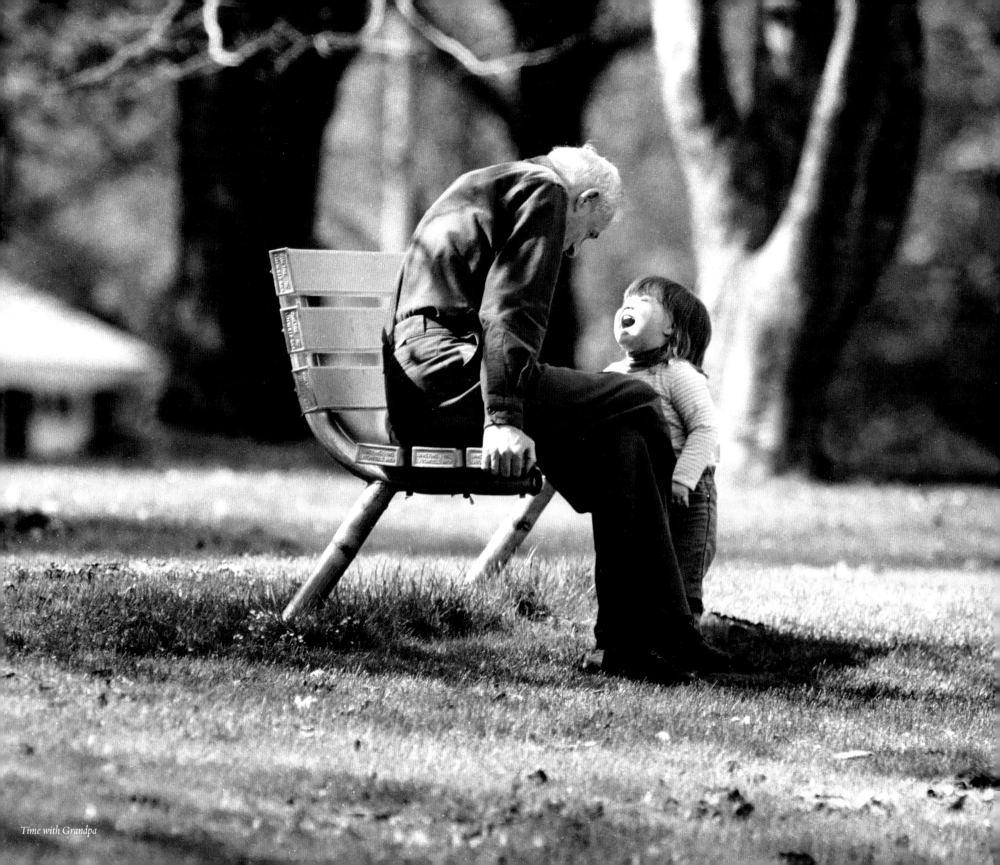

Time with Grandpa

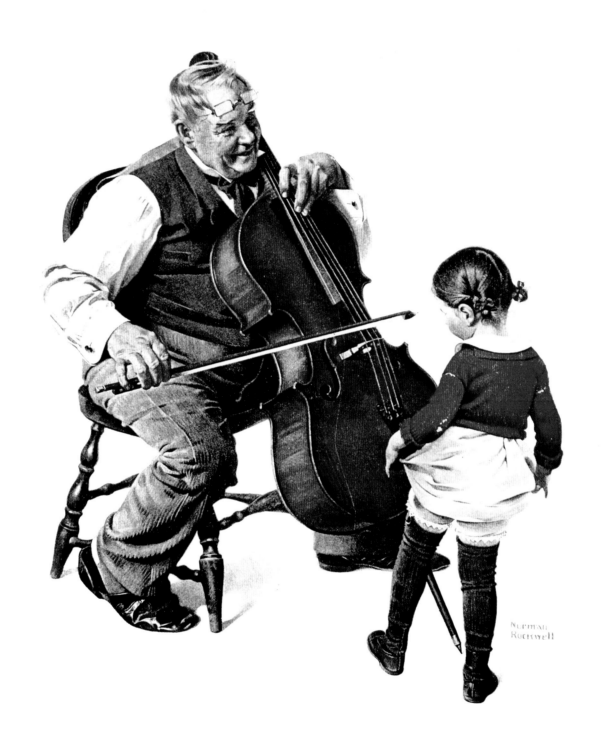

WHEN WE SEE

INNOCENCE,

WE ARE

LOOKING

THROUGH

GOD'S EYES.

IN THAT WAY,

NORMAN

ROCKWELL

WAS BLESSED.

—*Dolly Parton*
Award-winning singer/
songwriter, actress

Grandpa's Little Ballerina © 1923 *SEPS*

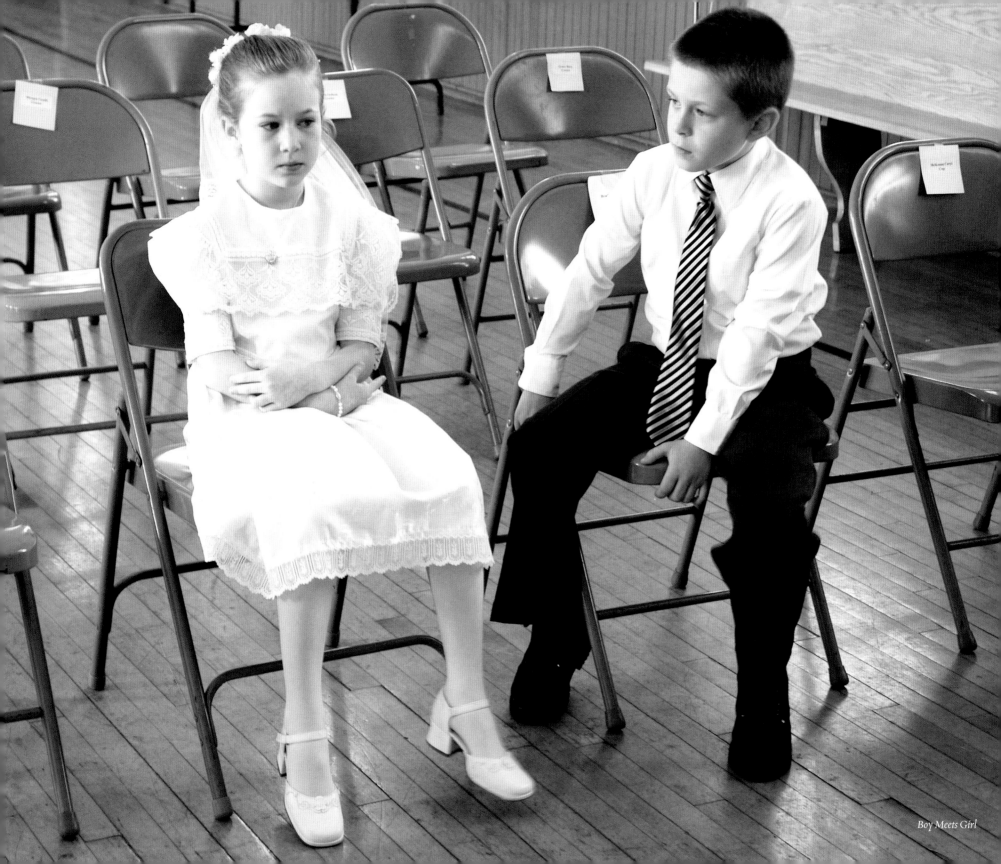

Boy Meets Girl

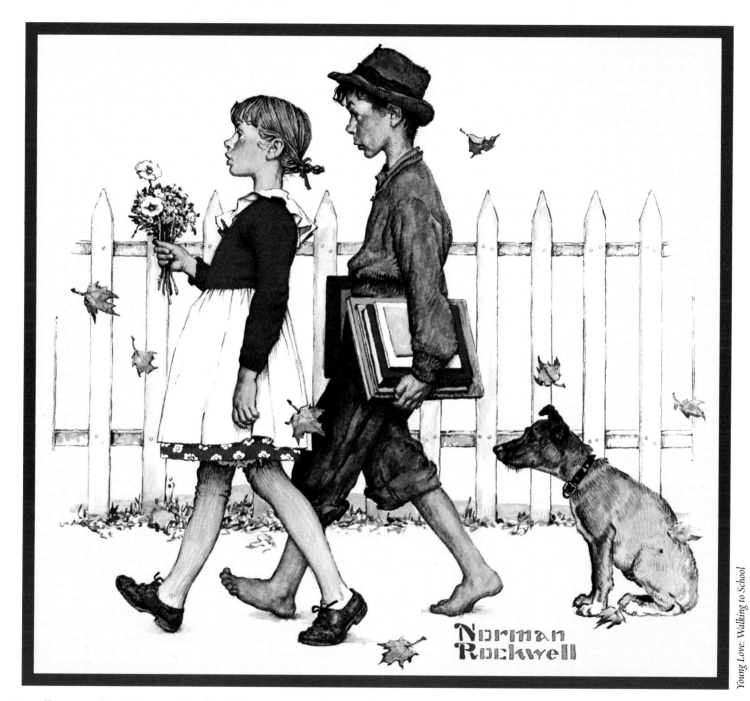

Young Love: Walking to School

I well remember Norman Rockwell's covers on *The Saturday Evening Post,* which as a kid, I sold on the street corners of New York City. I was raised in the city and always wished I looked like the boy with red hair on the magazine cover. It was a great time in America, and Mr. Rockwell's art made us aware and proud of our country and the people in it.

—*Regis Philbin*

Emmy award-winning television personality

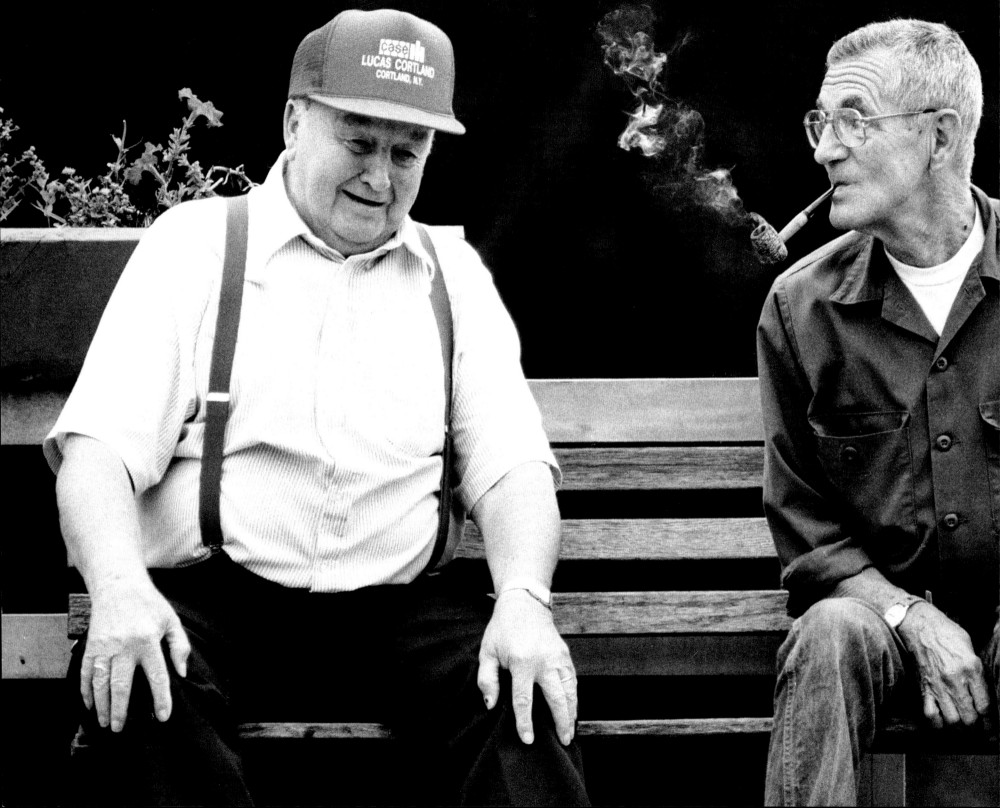

Old Friends

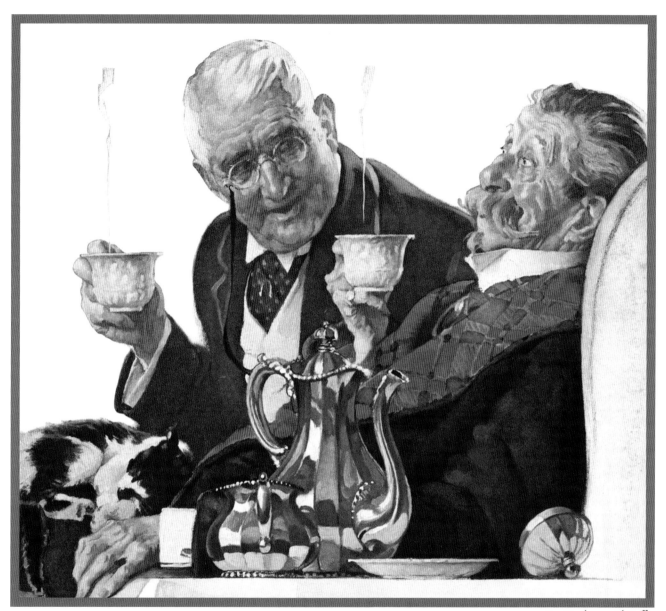

Two Gentlemen with Coffee

When imagining what life was like in the 1930s, 40s, and 50s, many Americans picture something similar to a Norman Rockwell painting. His pictures always remind me of what my family would have looked like had someone painted us when I was a child. We would have been on our front porch with Mom and Dad in the swing and the kids playing around. Rockwell's paintings make you feel like you're walking down the street in your hometown. They're a reminder of the good old days when life wasn't as hurried as it is now, and that is the quality that makes them so special.

—*Richard Petty*
NASCAR legend

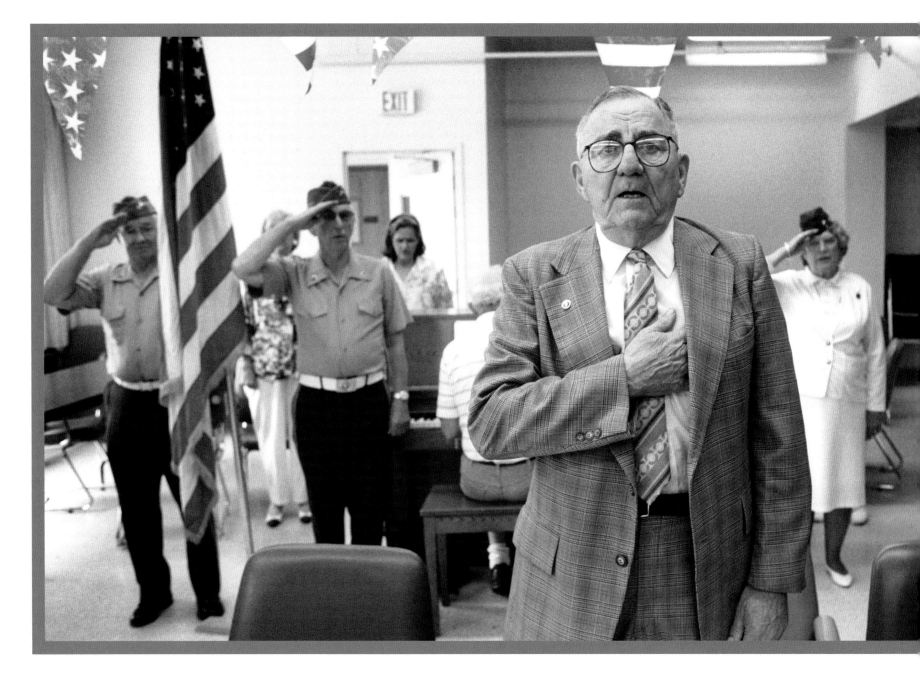

I have admired Norman Rockwell's work for as long as I can remember. His insightful work—often filled with optimism and humor—accurately and affectionately shows America and Americans at their best.

—*Edwin E. "Buzz" Aldrin*
Astronaut, Apollo 11

Pledge of Allegiance

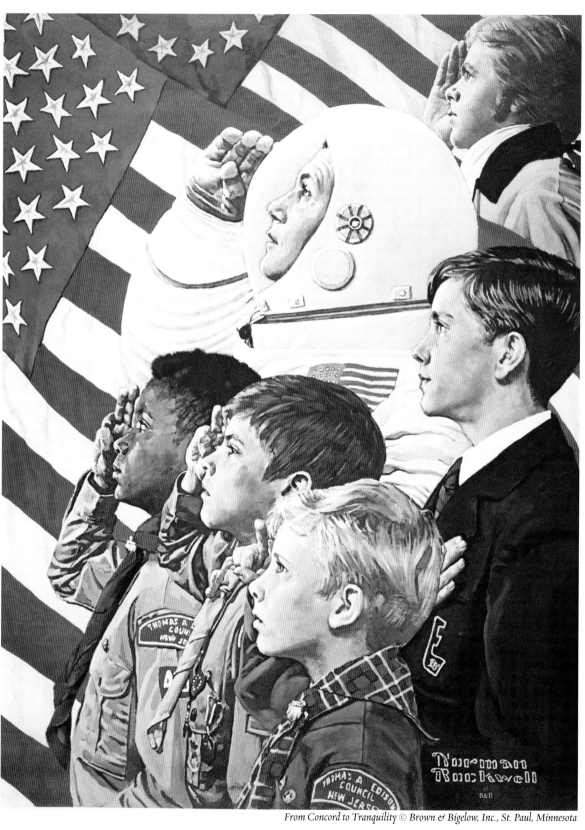

From Concord to Tranquility © Brown & Bigelow, Inc., St. Paul, Minnesota

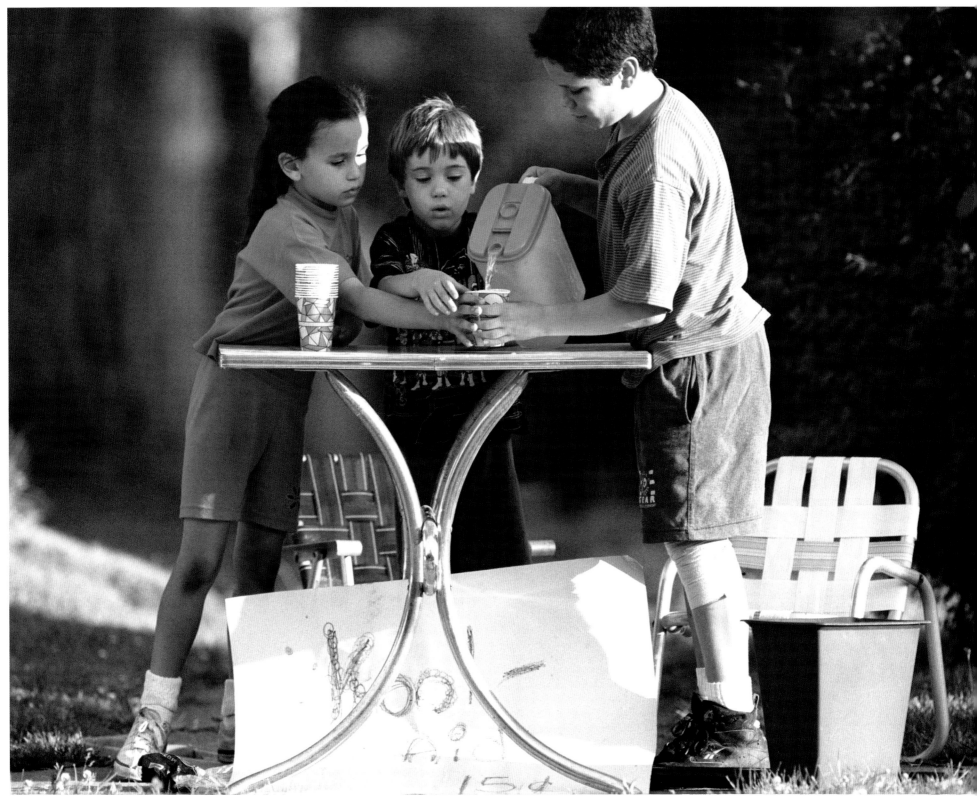

Kool-Aid Stand

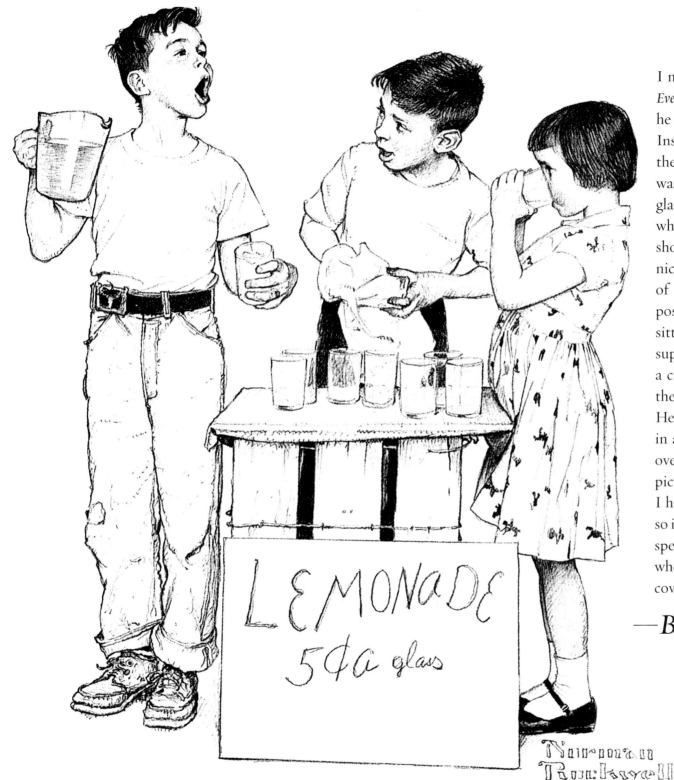

I modeled for Mr. Rockwell for a *Saturday Evening Post* cover as well as for drawings he did for the Massachusetts Mutual Life Insurance Company. I'm the little girl in the drawing *Lemonade Stand*. I remember he was very particular about how I held the glass when I was posing. He knew exactly what he wanted and would direct you or show you how to pose but was always very nice. I'm also the little girl in the audience of the drawing *Circus*. When we were posing for *Circus*, there were four models sitting in chairs on a table. We were supposed to look like we were watching a circus, but Mr. Rockwell wasn't getting the facial expressions he wanted from me. He took the popcorn out of my hands and, in an attempt to surprise me, threw it all over us just as the photographer took the picture. He got the expression he wanted. I had no idea these images would become so important. As I got older I realized how special these experiences were, especially when I would see the *Saturday Evening Post* covers all over the country.

—*Betsy Campbell Manning*
Neighbor and model for Norman Rockwell

Lemonade Stand

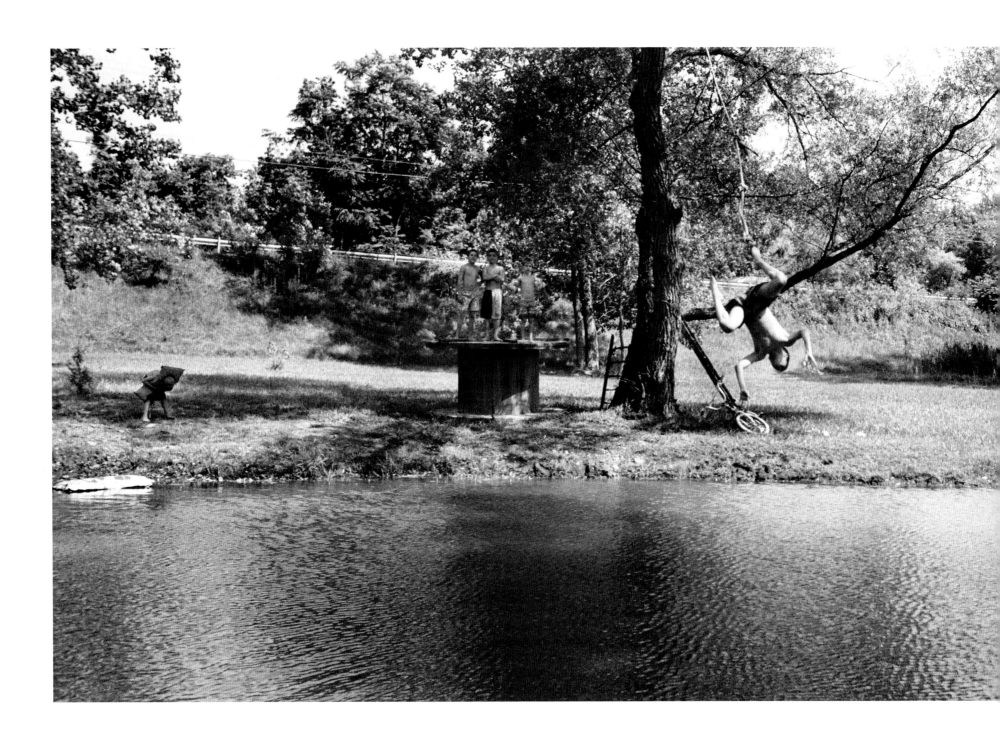

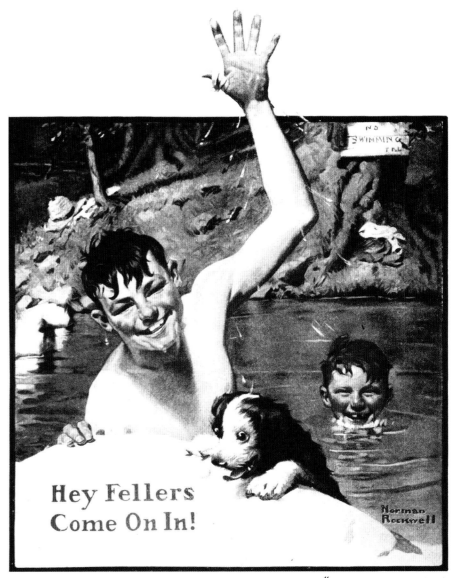

Hey Fellers Come On In © 1920 SEPS

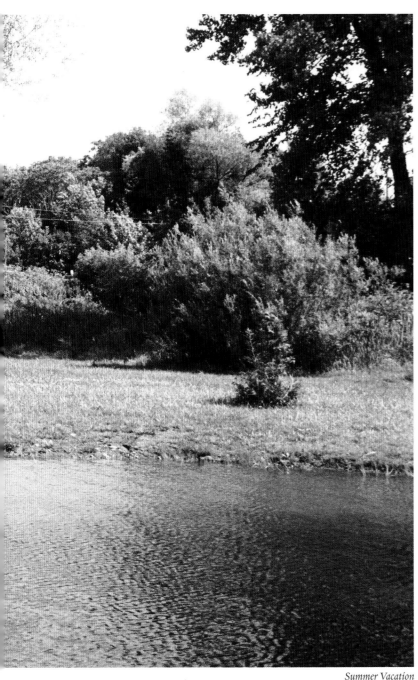

Summer Vacation

Norman Rockwell lived though some of the most tumultuous decades this country has ever seen—the Great Depression, two world wars, racial strife that threatened to tear us apart. Through all of this, he chose to focus on the more intimate moments that also shape and connect us. His paintings make us smile, think, and truly appreciate what we love about this country. He became one of America's greatest storytellers, embracing and celebrating on canvas the moments that we are sometimes too busy to appreciate. In his hands, these moments will live forever. It is Norman Rockwell's point of view that helps us to see who we really are when we think no one is looking. Lucky for us, he was.

—*Dr. Phil McGraw*
Psychologist, television personality, and author

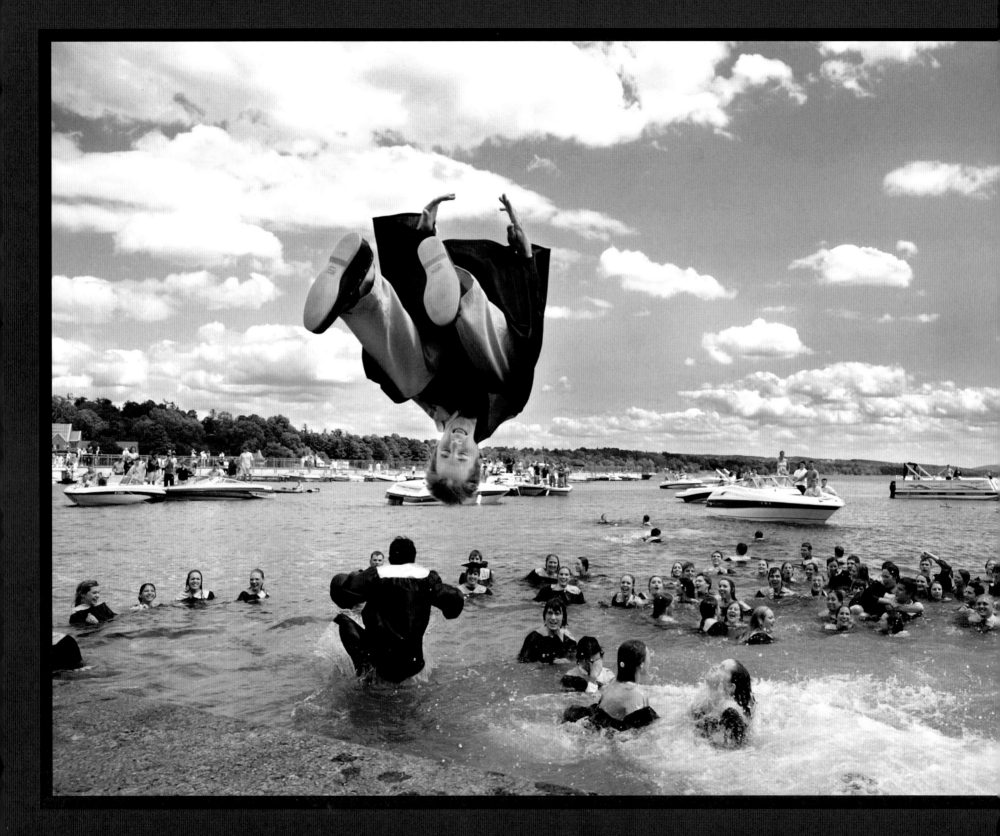

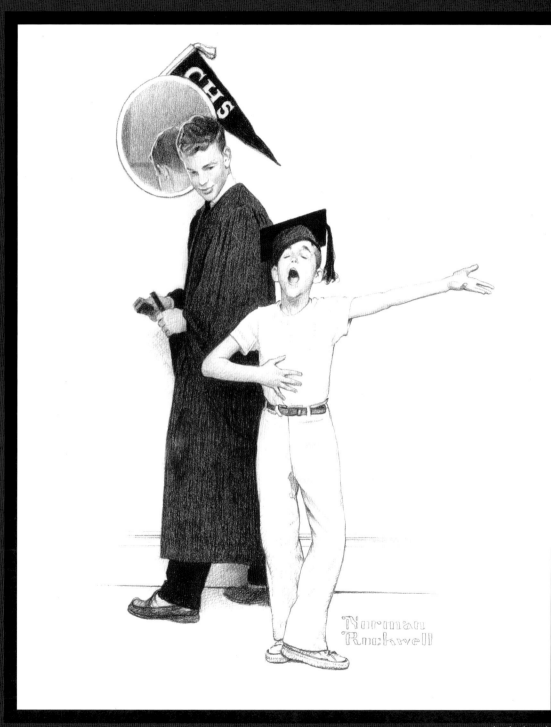

After winning the 1970 World Series MVP, I went to Norman Rockwell's studio in January 1971 to pose for a portrait commissioned by Figgie International, the parent company of Rawlings Sporting Goods.

I remember walking into the studio and immediately recognizing a lot of the covers I had seen on *The Saturday Evening Post*. Mr. Rockwell was a wonderful man and very knowledgeable about baseball. Both he and his art were very important to people of my generation.

The portrait he painted of me is one of the last large color canvases Rockwell completed before his death. It is the only portrait that Rockwell painted of an individual baseball player. Some of the faces in the crowd can be identified among the cast of models Rockwell frequently selected from his family, friends, and neighbors. His assistant, Louie Lamone, appears at the left with his hand near his mouth, and his Stockbridge neighbors the Bergmans are also shown, including Harry (the man with the tie), Sally (the woman with glasses), and daughter Johanna (the girl at right). Young Hank Bergmans is featured as the boy with the baseball mitt receiving my autograph, and Rockwell included his own self-portrait in the cheering man biting down on the cigar.

When Figgie International was sold, I was fortunate to obtain the original painting. It has brought me great pleasure. Rockwell is America, and I'm proud to be a part of this history.

—*Brooks C. Robinson*
Baseball Hall of Fame, 1983

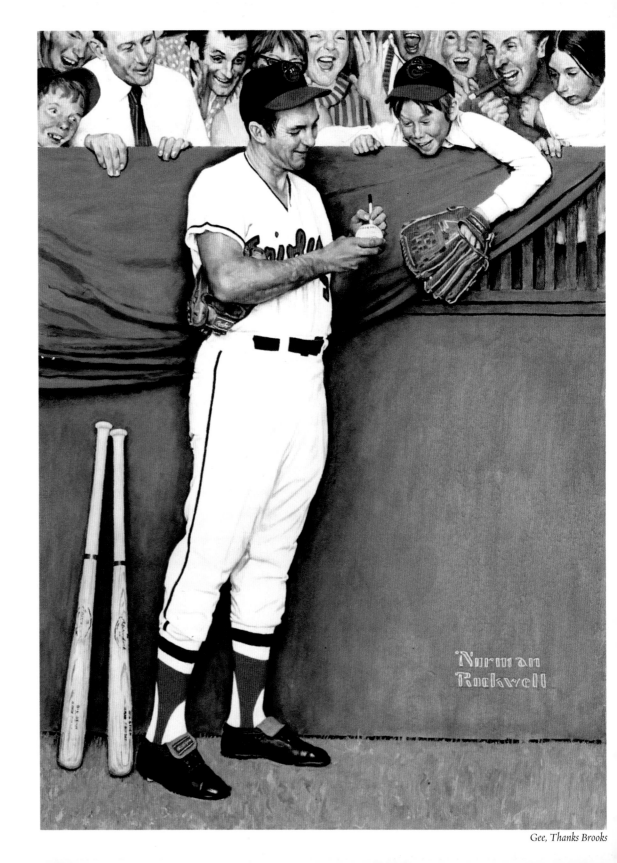

Gee, Thanks Brooks

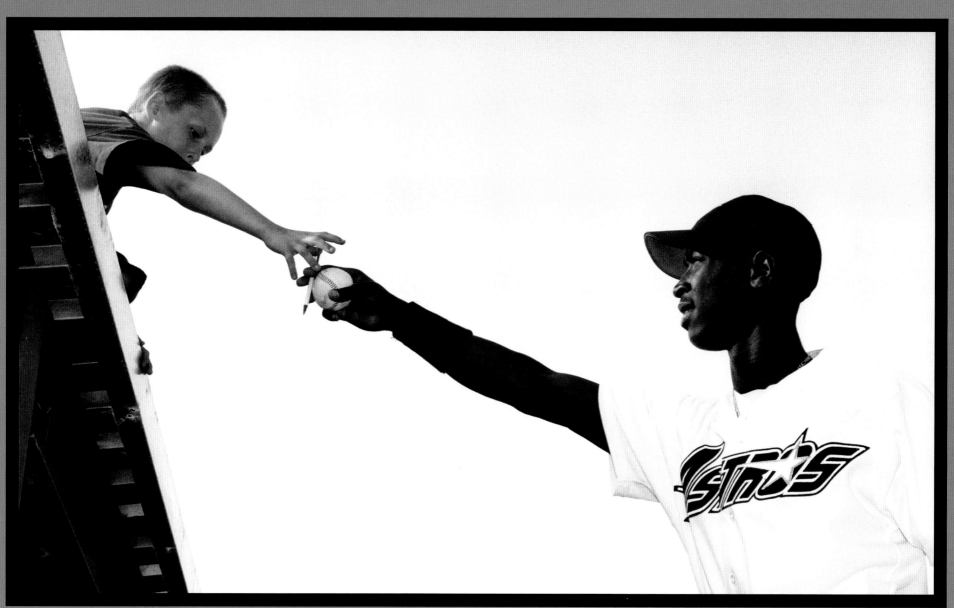

Autograph

Closer Look

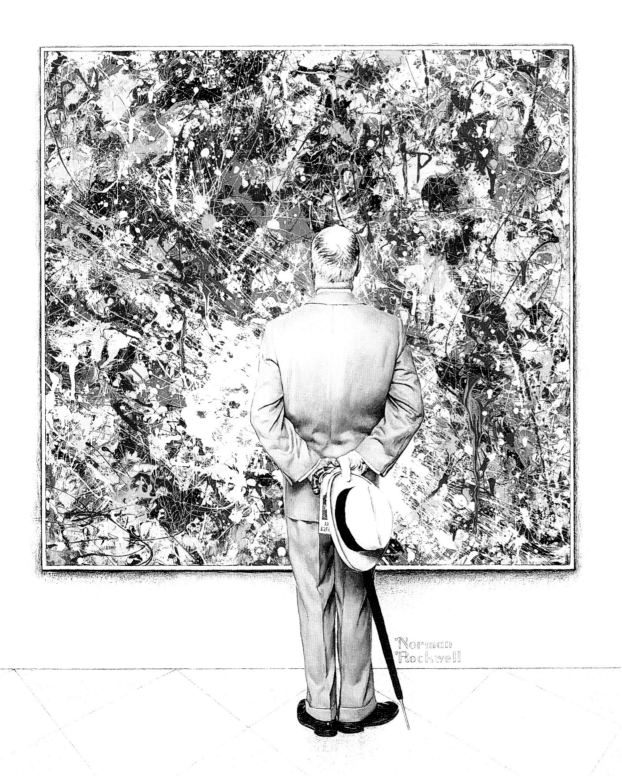

NO MAN WITH

A CONSCIENCE

CAN JUST BAT OUT

ILLUSTRATIONS.

HE'S GOT TO PUT

ALL HIS TALENT

AND FEELING

INTO THEM!

—*Norman Rockwell*

Art Connoisseur © 1962 SEPS

NORMAN ROCKWELL IS

WITHOUT PEER IN HIS ABILITY

TO DEPICT LIFE ACCURATELY

AND AMUSINGLY. HE WILL BE

REMEMBERED BECAUSE HE

PAINTED PEOPLE AS HE SAW

THEM, AND HIS ART WILL BE A

HISTORY OF OUR TIMES.

—*J. C. Hall*
Founder of Hallmark Cards, Inc.,
in his autobiography When You Care Enough

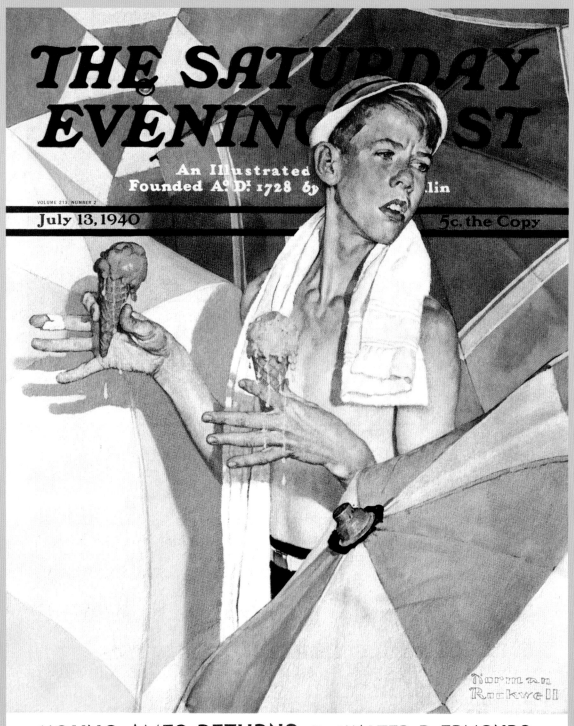

THE SATURDAY EVENING POST

An Illustrated
Founded A.D. 1728 by ...lin

VOLUME 213, NUMBER 2

July 13, 1940 5c. the Copy

Norman Rockwell

YOUNG AMES RETURNS By **WALTER D. EDMONDS**

Joys of Summer © 1940 SEPS

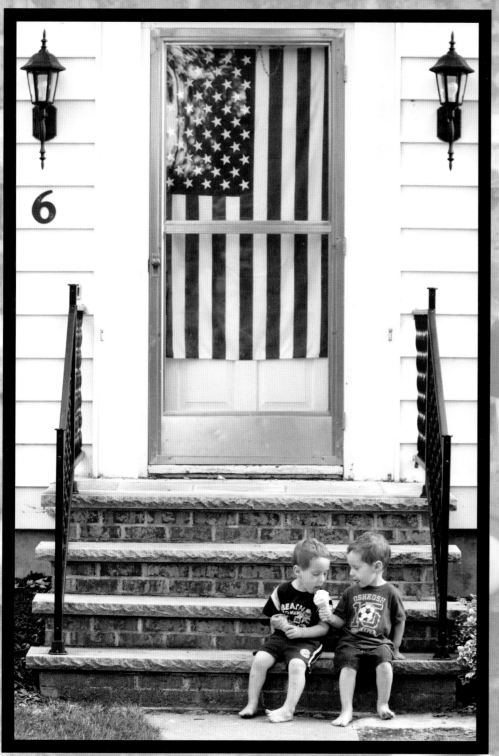

Sharing a Cone

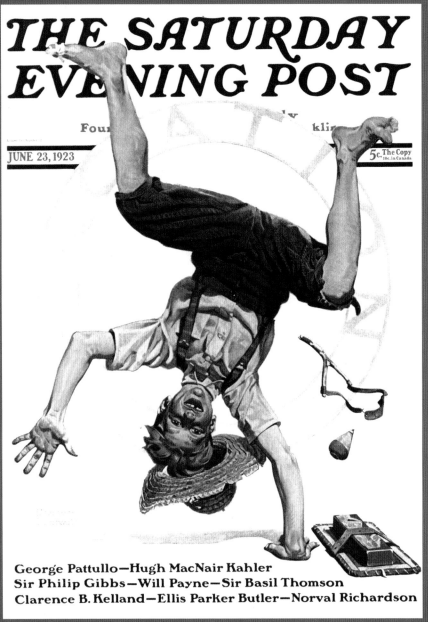

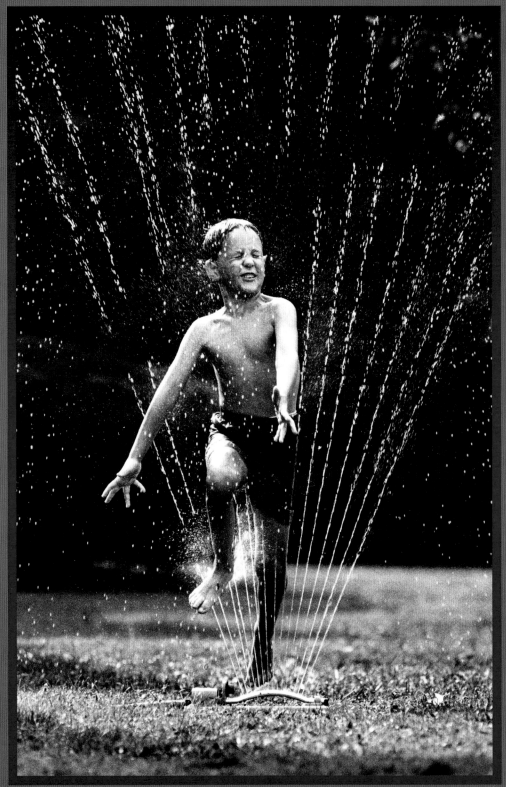

Sprinkler

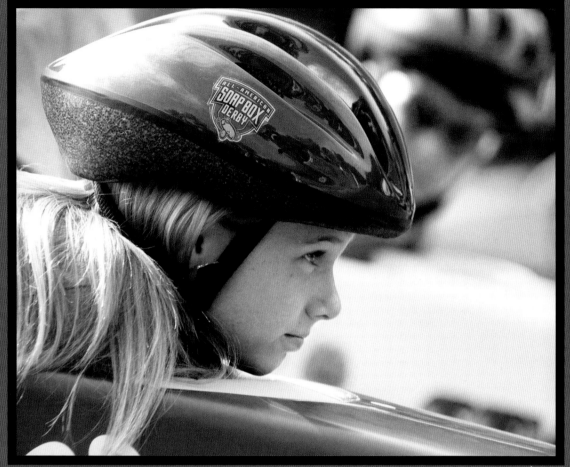

Lady Driver

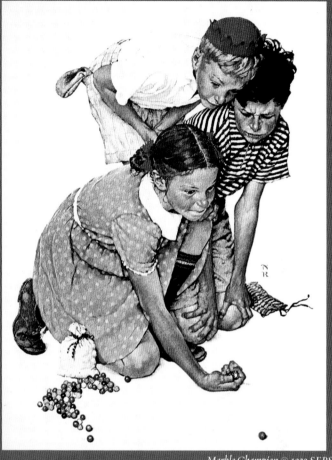

Marble Champion © 1939 SEPS

I have always felt that Norman Rockwell was speaking to children living in small towns across America—like Bentonville, Arkansas, where I grew up. In the 1950s and early 1960s we were raised in magical places where it was safe, and the slower rhythms of childhood could be felt and understood. Looking back across the decades, we find it hard to believe that Rockwell's America ever existed.

I suppose Rockwell's genius can be described as an ability to see the world through his own child's eye, to recapture wonder, newness, delight, and the small and large terrors of life, as if experienced or noticed for the first time. That and his uncanny eye for evoking with gentle humor the imperfections that confirm our common humanity—his own prodigious Adam's apple being only the most conspicuous example.

There are, of course, geographical, chronological, and technical differences between Rockwell's paintings and Kevin Rivoli's photographs. But both capture and celebrate everyday life and its small yet consequential moments that are often what we share across time and distance.

—*Alice Walton*
Chairman, Crystal Bridges Museum of American Art

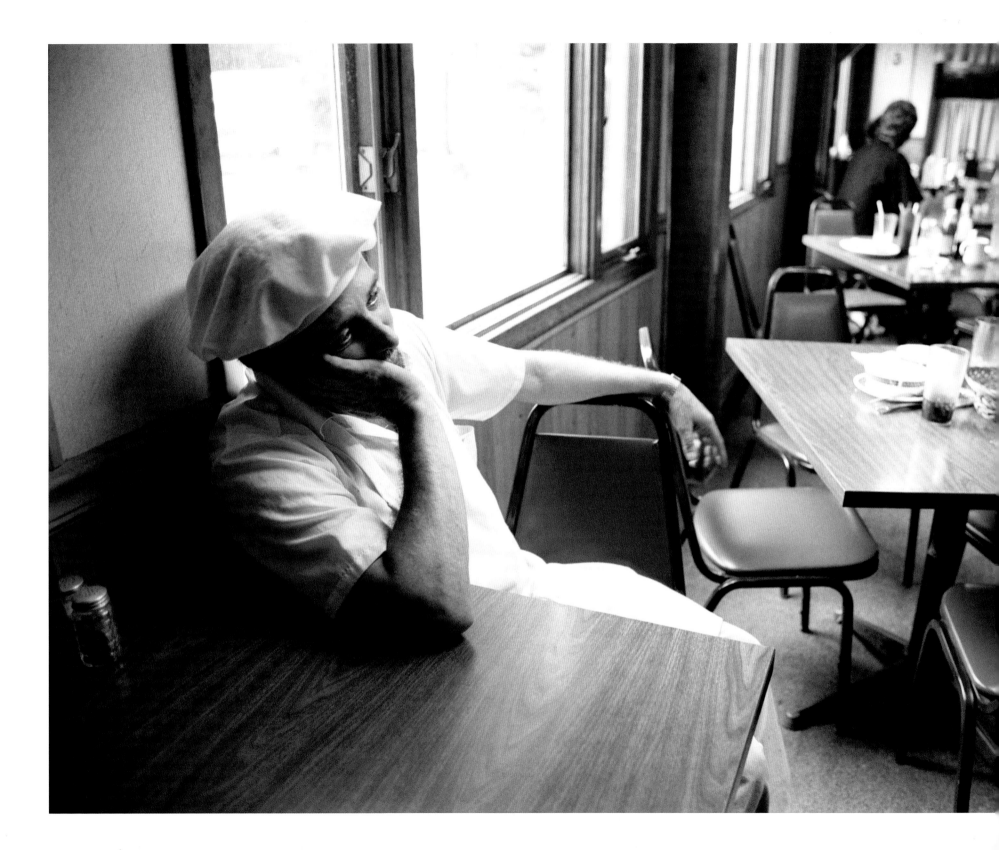

In Between Meals

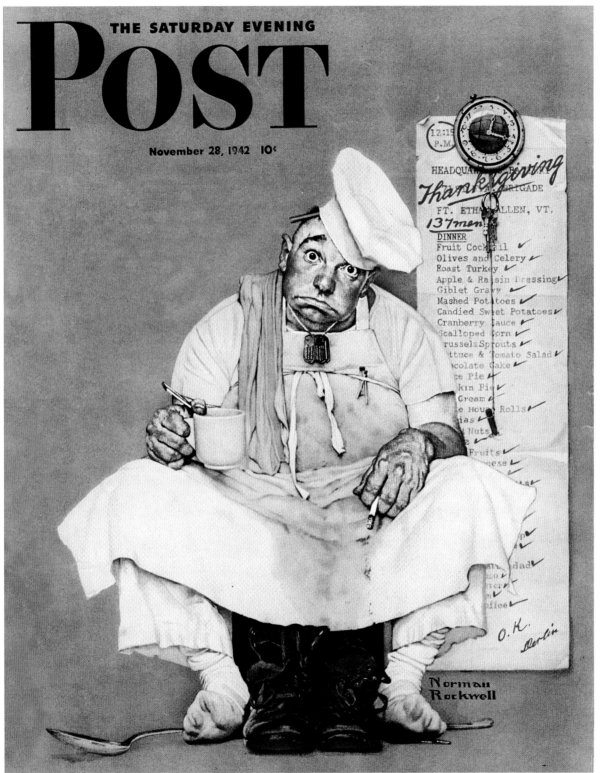

Thanksgiving Blues © 1942 SEPS

WHEN PAINTING A

POST COVER

I MUST TELL

A COMPLETE,

SELF-CONTAINED

STORY.

—*Norman Rockwell*

In 1977, Norman Rockwell was awarded the Presidential Medal of Freedom, America's highest civilian award. The award honored a man whose career spanned some of the most significant decades in American history and whose work often reflected the times—from the celebration of a G.I. returning home from war to the desegregation of schools to man's first walk on the moon. But Norman Rockwell is best known for his work that celebrates the everyday moments of life—the joys of childhood, the awkwardness of adolescence, the importance of family, and the love of country. His work often shows the very best of American values and captures the quintessential American spirit that lives in each of us.

— *President Jimmy Carter*

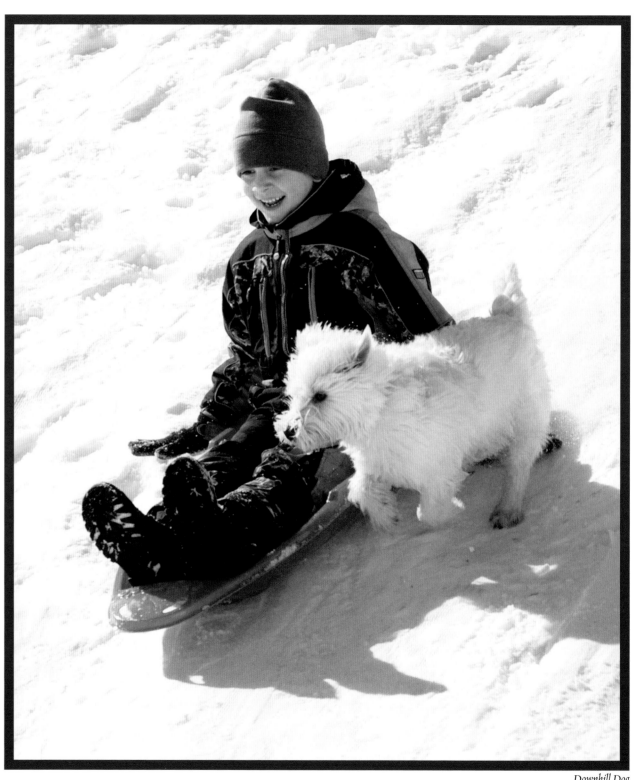

Downhill Dog

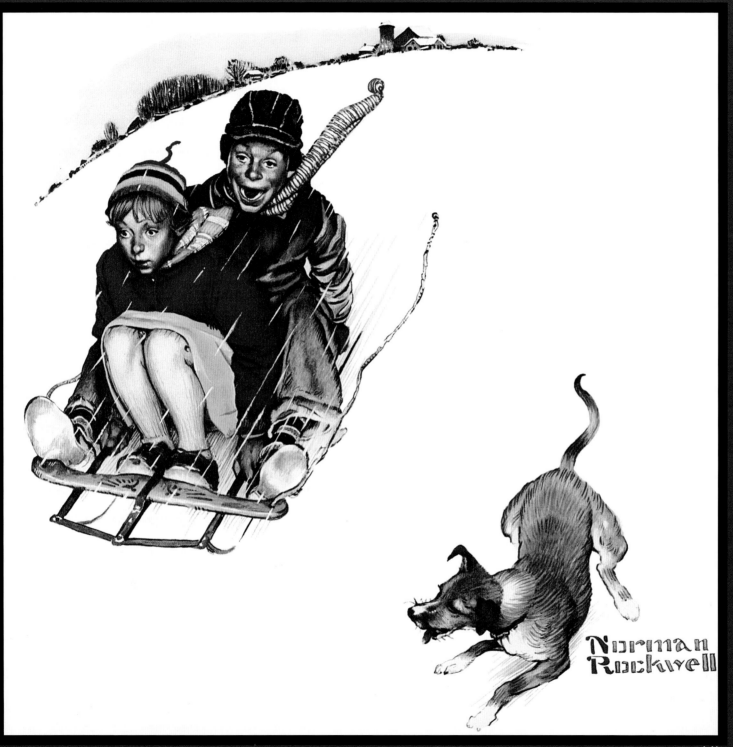

HIS WORK

OFTEN SHOWS

THE VERY BEST

OF AMERICAN

VALUES

AND CAPTURES

THE QUINTES-

SENTIAL

AMERICAN

SPIRIT

THAT LIVES

IN EACH OF US.

Young Love: Sledding

One of the most difficult problems in painting magazine covers is thinking up ideas which a majority of readers will understand. The farmer worries about the price of milk; the housewife fusses over the drapes for the dining room; the gossip gossips about Mrs. Purdy and her highfalutin airs. You have to think of an idea which will mean something to all of them. And it's darned hard to be universal, to find some situation which will strike the farmer, the housewife, the gossip, and Mrs. Purdy.

In wartime the problem vanishes. Everyone in the country is thinking along the same lines; the war penetrates into everyone's life. Johnny Sax, the boy next door, joins up; sugar can't be bought for blood or money; the war bond posters are plastered all over town.

Take the *Post* cover I did at the end of World War II of a soldier coming home. That scene was repeated all over the United States—in the slums of the big Eastern cities; in the country towns of the Middle West; in Dallas, Seattle, Peoria, and Musselshell, Montana. I could be pretty sure that nobody would scratch his head and say, "Now what is that soldier standing in the backyard for? And why, in the name of all that's holy, is that woman delightedly screaming at him?"

—*Norman Rockwell*

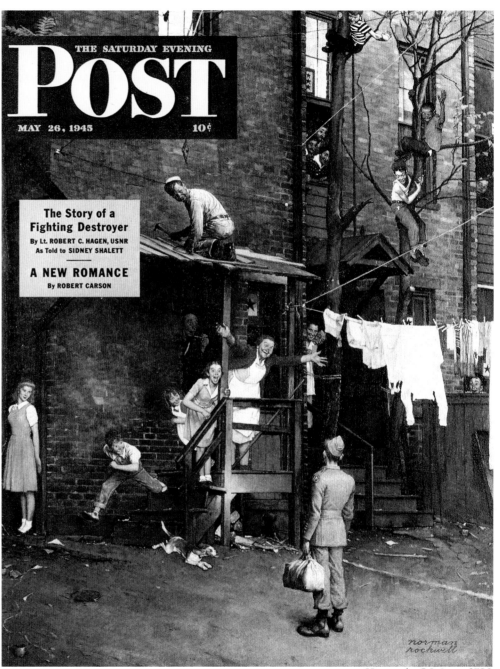

Homecoming G.I. © 1945 SEPS

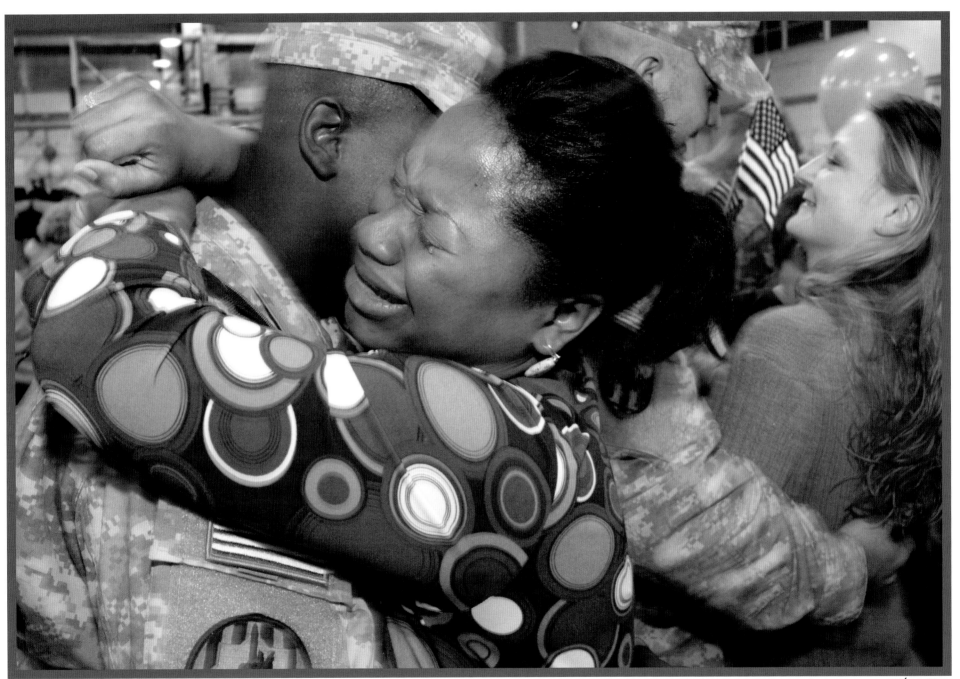

Welcome Home

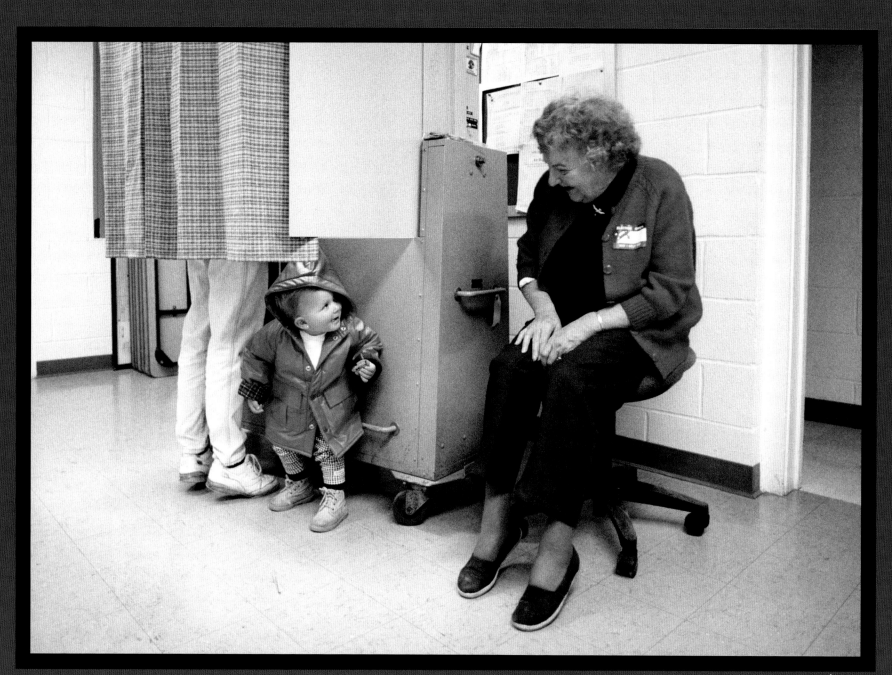

Election Day

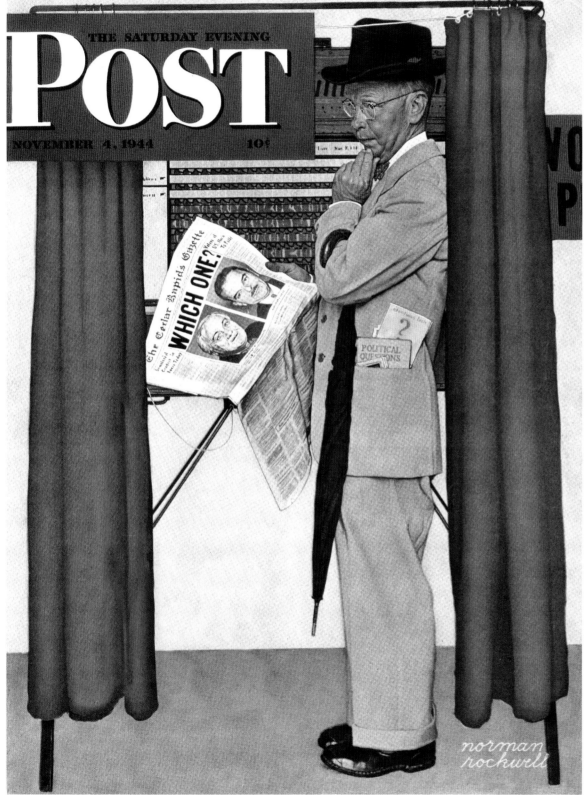

Undecided © 1944 SEPS

I've loved Norman Rockwell ever since I was a little girl. I grew up with his work appearing on the cover of *The Saturday Evening Post,* so I've always known who he was and was familiar with his work. My mother loved him too. She did needlepoint, and at one time a whole series of his work was released in needlepoint patterns. My mother bought all of them and did every one. When she was finished, she often turned the work into pillows. She would give one to my son, Todd, every year on his birthday. The first one she did for him was based on Rockwell's *100 Years of Baseball* painting. Todd still has all of them.

Once when I was on vacation in Europe with my daughter, Carrie, and Todd, we ran into the Rockwells in the lobby of a Bristol Hotel in Paris. We sat having tea with them for hours. My children, who were about eleven and twelve at the time, were absolutely mesmerized by Mr. Rockwell. He was one of the most enchanting and talented people we had ever met, and we all loved him and his wife. They were both extraordinary. That encounter made such an impression on us that when Todd was a young man he began to collect Rockwell's work. He bought an original pencil sketch and a lithograph before he was eighteen and has a copy of Rockwell's famous *Four Freedoms* hanging in his home today.

We had a great time meeting him, and we've never forgotten it. In fact, we still talk about it today. Rockwell was the artist of America and Americana.

—*Debbie Reynolds*
Academy award-nominated actress, singer, and dancer

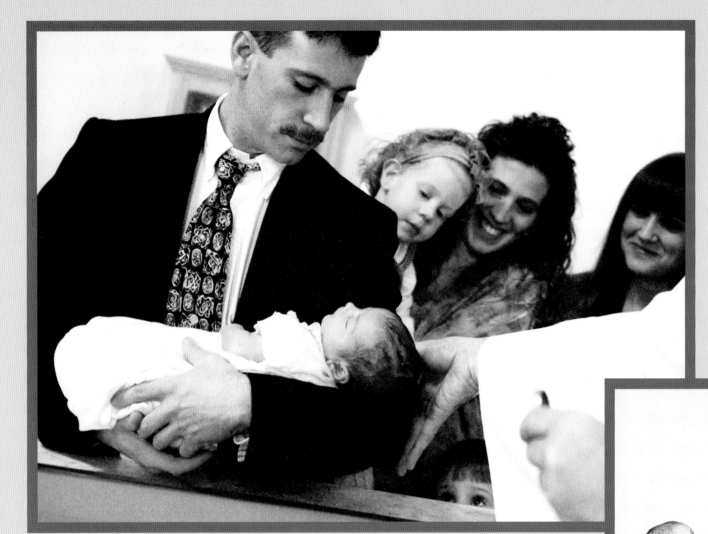

Baptism

With the fast pace of life today, Rockwell's work slows us down to contemplate those moments in life that are seemingly insignificant at first, but capture the essence of our collective experience of life for family, friends, and ourselves. Rockwell's art captures the triumph and tribulations that we've been through all of our lives, and creates lasting memories for all of us.

—*Peggy Fleming*
Internationally known figure skating champion and Olympic gold medalist

Becoming Parents

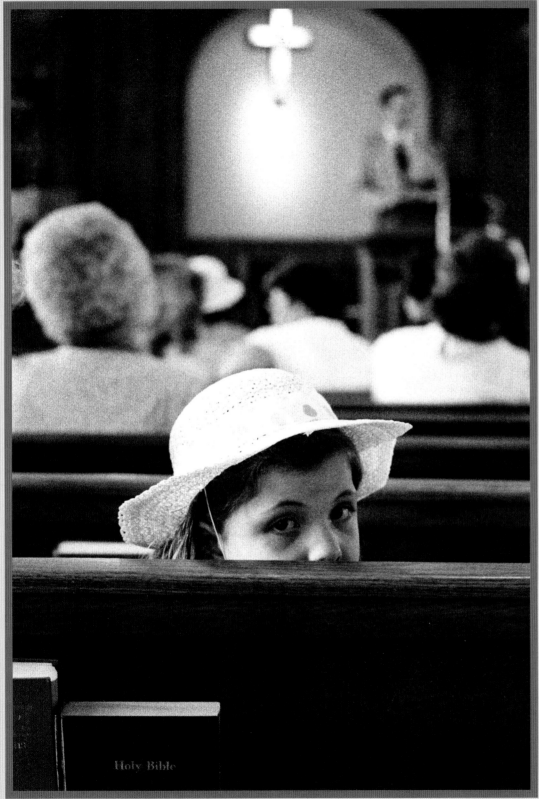

Sunday Service

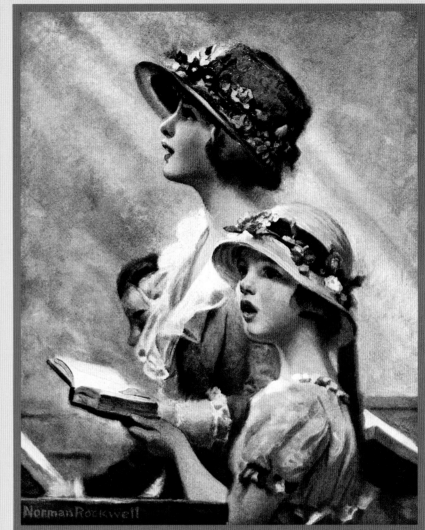

Mother and Daughter Singing in Church

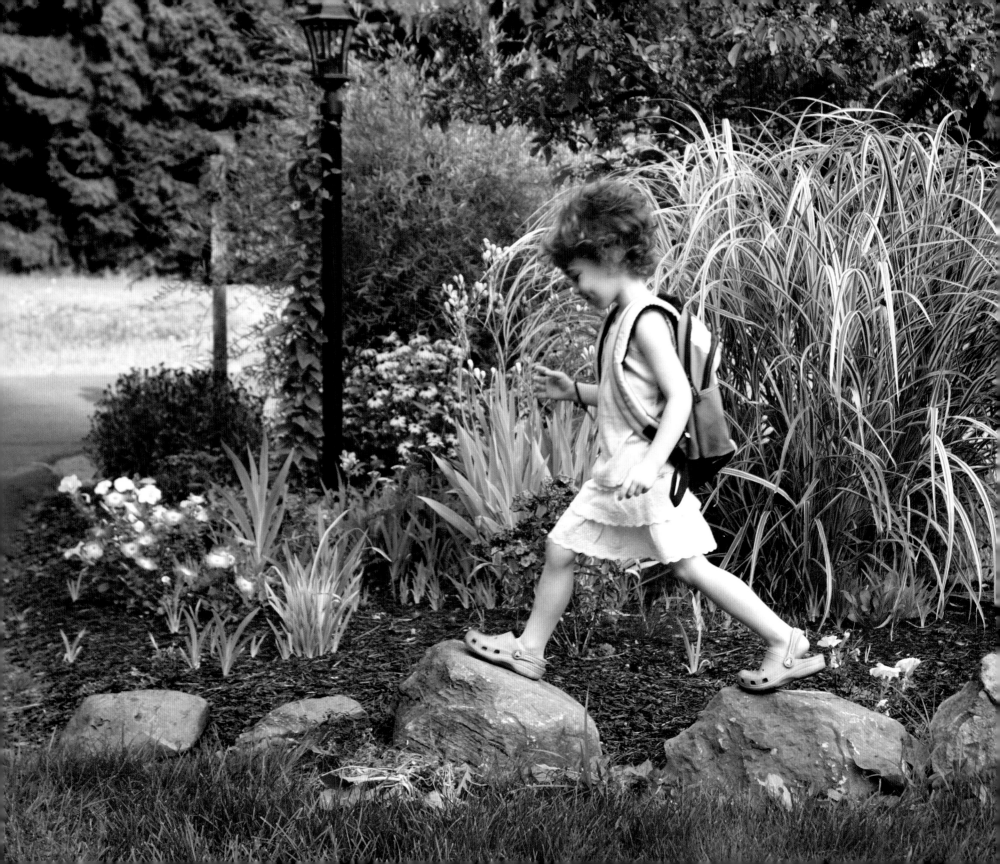

First Day of School

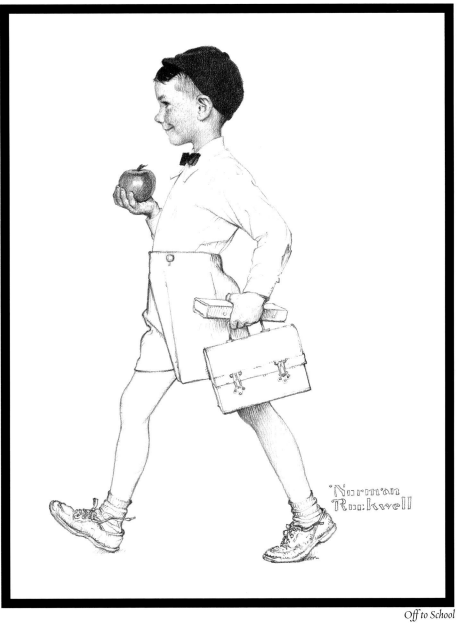

Off to School

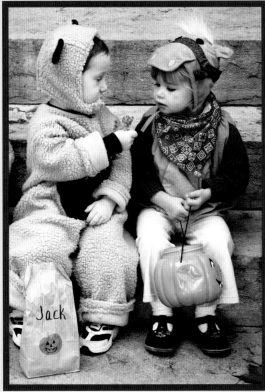

Holiday Sweets

We look at Norman Rockwell, then look at the world around us and think of our own world as too ruthless for Norman Rockwell. We should remember that Rockwell painted his way through rough and dangerous times, through two world wars, a major depression, and a cultural revolution. Rockwell trained himself to isolate the little victories that we win in the midst of global strife. Today, we need to train ourselves, as well, to see what's always there. This book is an apt guide to this civilizing project.

—Dave Hickey
Art and cultural critic, author

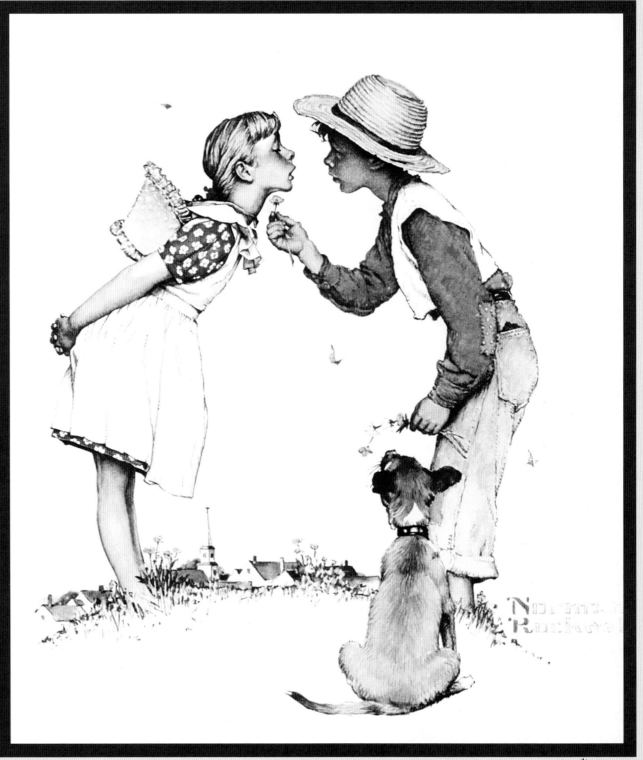

Beguiling Buttercup

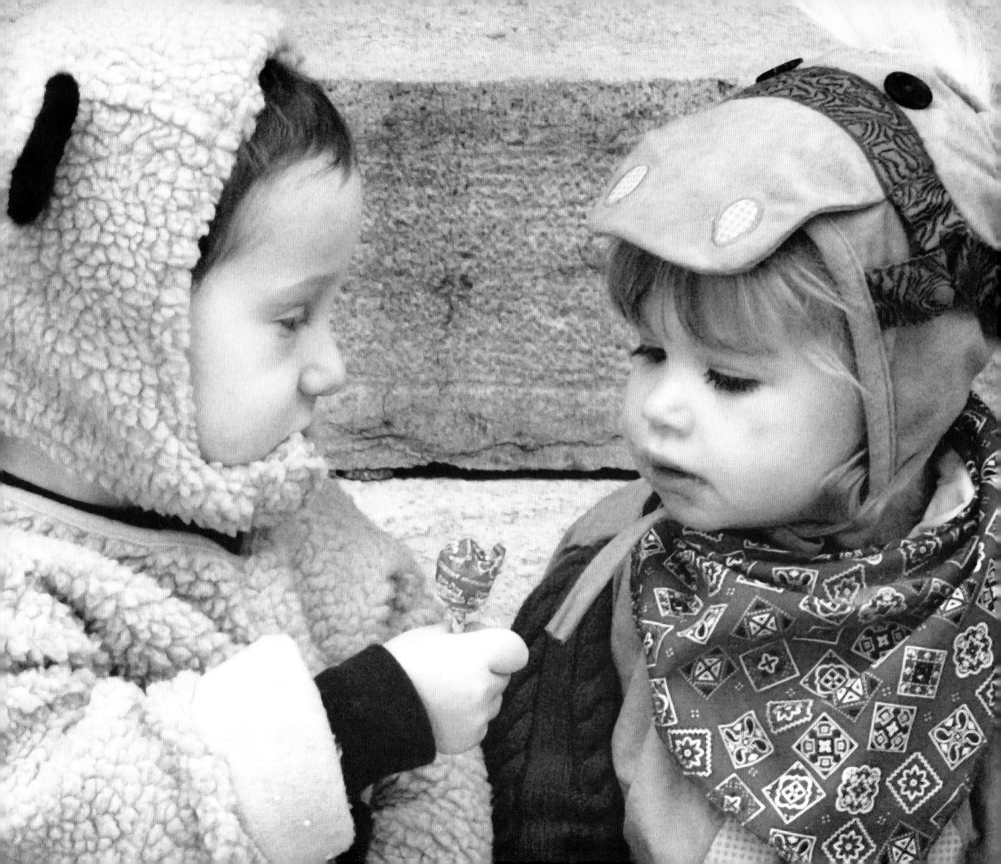

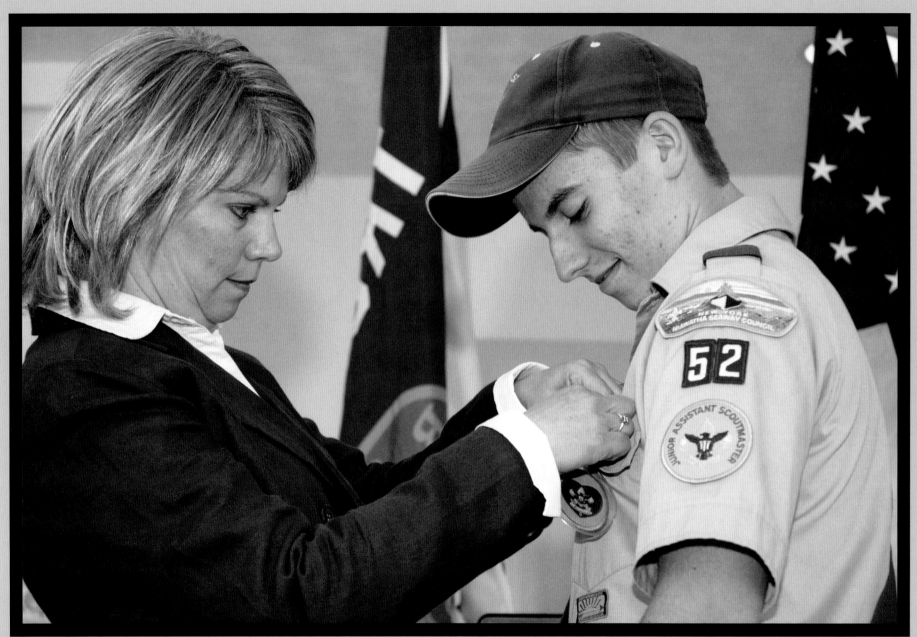

Eagle Scout

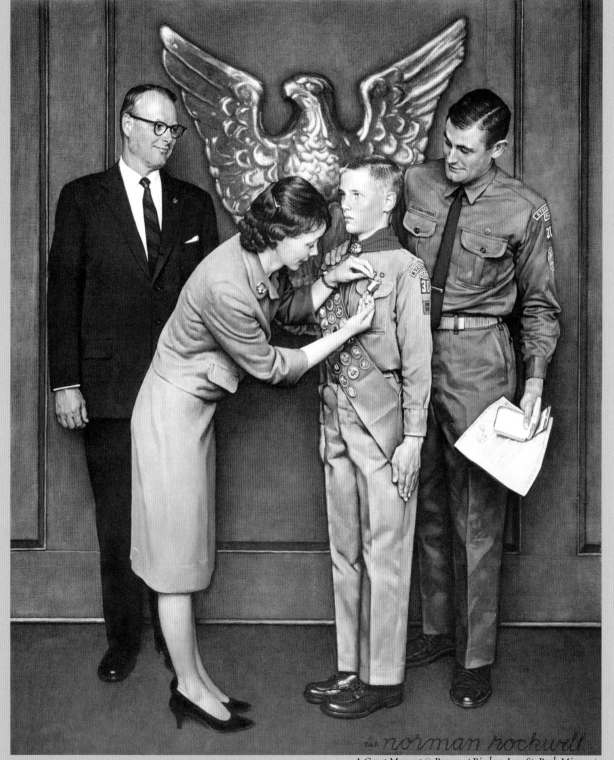

A Great Moment © Brown & Bigelow, Inc., St. Paul, Minnesota

NORMAN ROCKWELL'S BOY SCOUT ART WAS THE HEART OF WHAT THE SCOUTING MOVEMENT WAS ALL ABOUT. HIS PAINTINGS WERE TO ME THE INSPIRATION TO FOLLOW THE MEANING OF HIS TALENTED BRUSH. WHEN I THINK OF MY LIFE AS AN EAGLE SCOUT, I THINK OF NORMAN ROCKWELL.

— *Captain Jim Lovell*
NASA astronaut and commander of Apollo 13

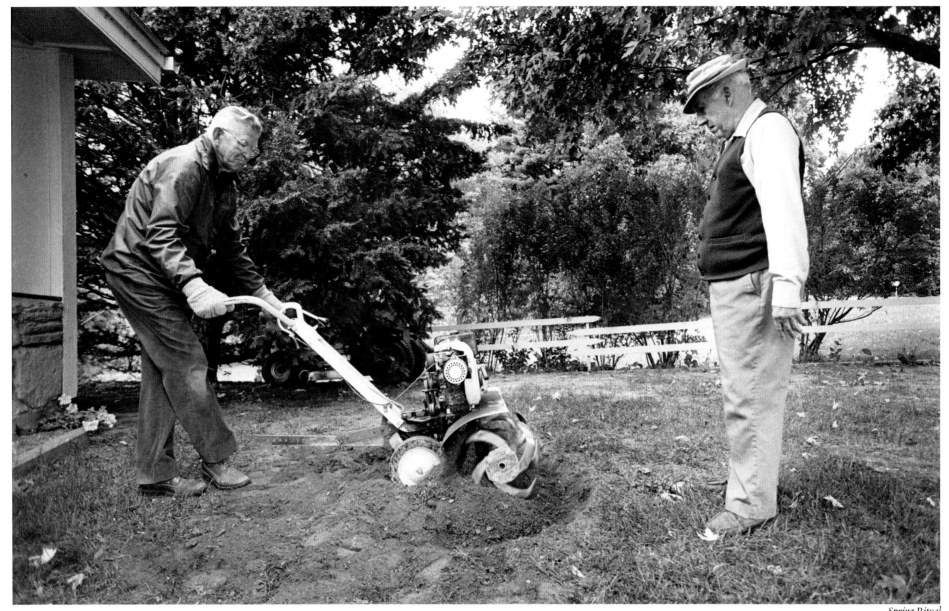

Spring Ritual

GUESS I NEVER REALLY BELONGED IN WESTCHESTER.

I WAS NEVER REALLY HAPPY THERE. BUT THE HARD-DIRT FARMERS IN VERMONT—

WHEN I GOT WITH THEM, IT WAS LIKE COMING HOME.

—*Norman Rockwell*

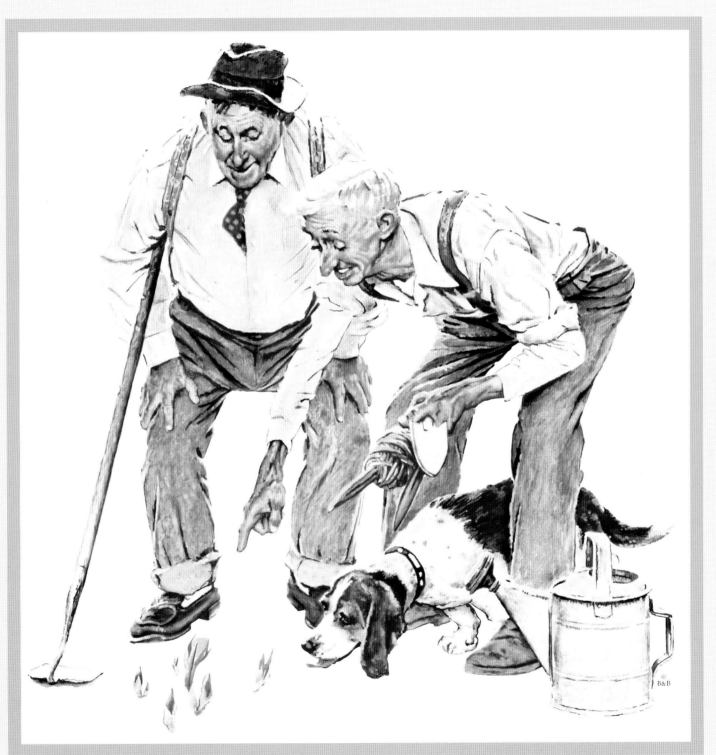

Shared Success © Brown & Bigelow, Inc., St. Paul, Minnesota

HE WAS A STICKLER

FOR DETAILS,

BELIEVING THAT

EVERY OBJECT

IN A PICTURE

HAD TO BE RIGHT.

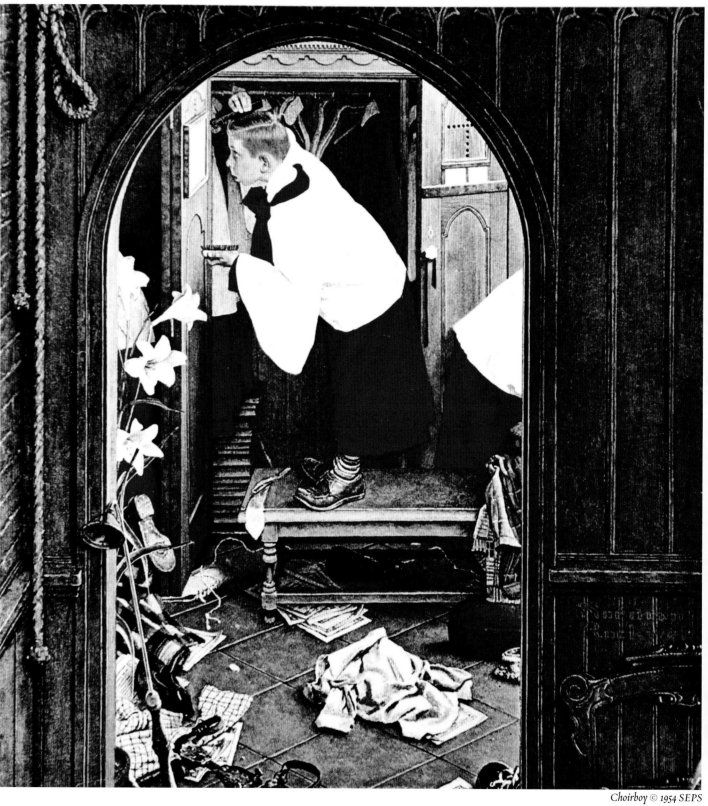

Choirboy © *1954 SEPS*

The Groom

The absolute realism of my father's pictures was the means he used to create the direct and unmediated relationship between picture and public. Everything was clearly and precisely depicted. He was a stickler for details, believing that every object in a picture had to be right. Every detail is shown with an equally precise realism. He never imagined a scene—a barbershop or a stable or a town clerk's office—but rather found a particular one to use as a model. Then he made sure that every detail was true to that place. Equally, there were no foggy corners of incomprehensible parts to confuse us. The pictures are so clear and detailed, so precisely and simply there in front of us, that they seem to present the story innocent of artifice. We can encounter the picture directly because it shows us a physical reality that we do not doubt.

—Peter Rockwell

Norman's son is a sculptor and writer who lives in Rome, Italy. This is from his essay "Some Comments from the Boy in a Dining Car" in the book Norman Rockwell: Pictures for the American People *(Abrams, 1999)*

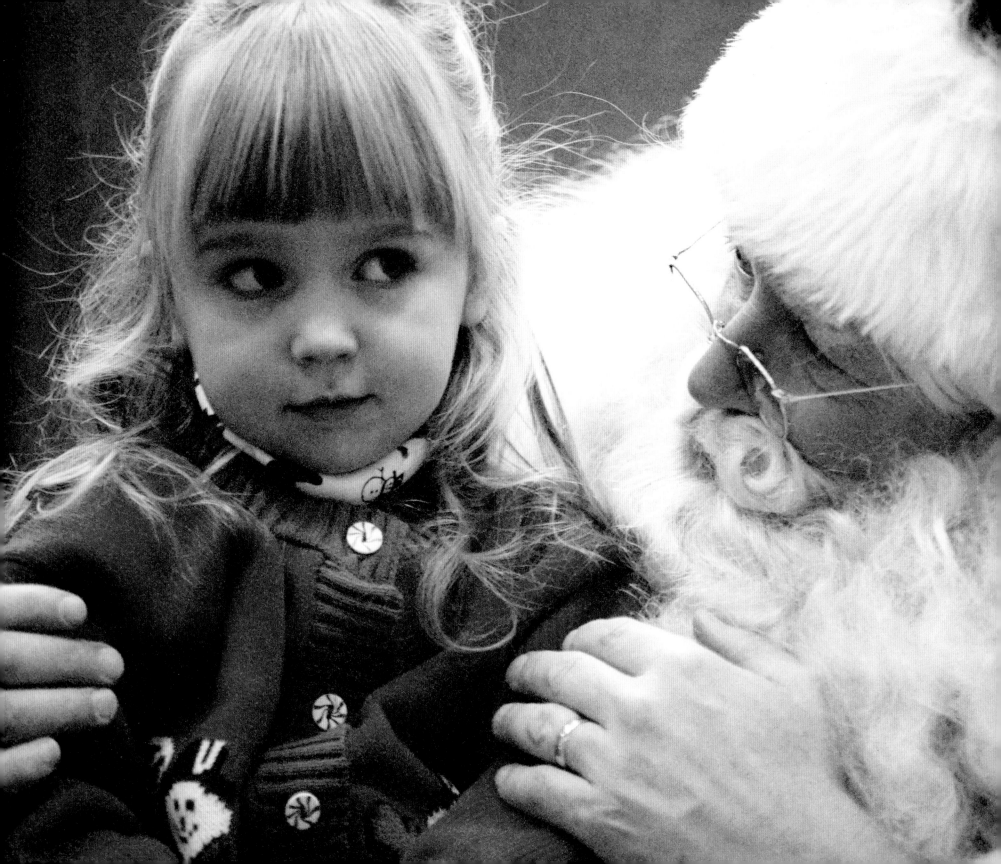

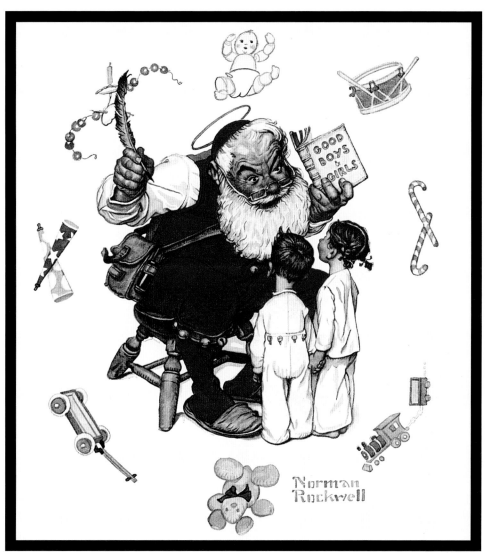

Santa's Visitors

I grew up with the illustrations of Mr. Rockwell. His pictures were humorous and yet poignant. Somehow he was able to capture not only the heart of America but the very core of the human spirit. He inspired me to value the traditions of the American way of life and to respect the diversity of our country. Today we miss his portrayals of the simple everyday guy whom we loved. There was a kindness in his art that reminds us of so many facets of our complex lives that we have lost. I miss him.

—*Karolyn Grimes*

Former child actress who starred alongside some of the biggest names in Hollywood.
We all love and know her as Zuzu in the movie It's a Wonderful Life.

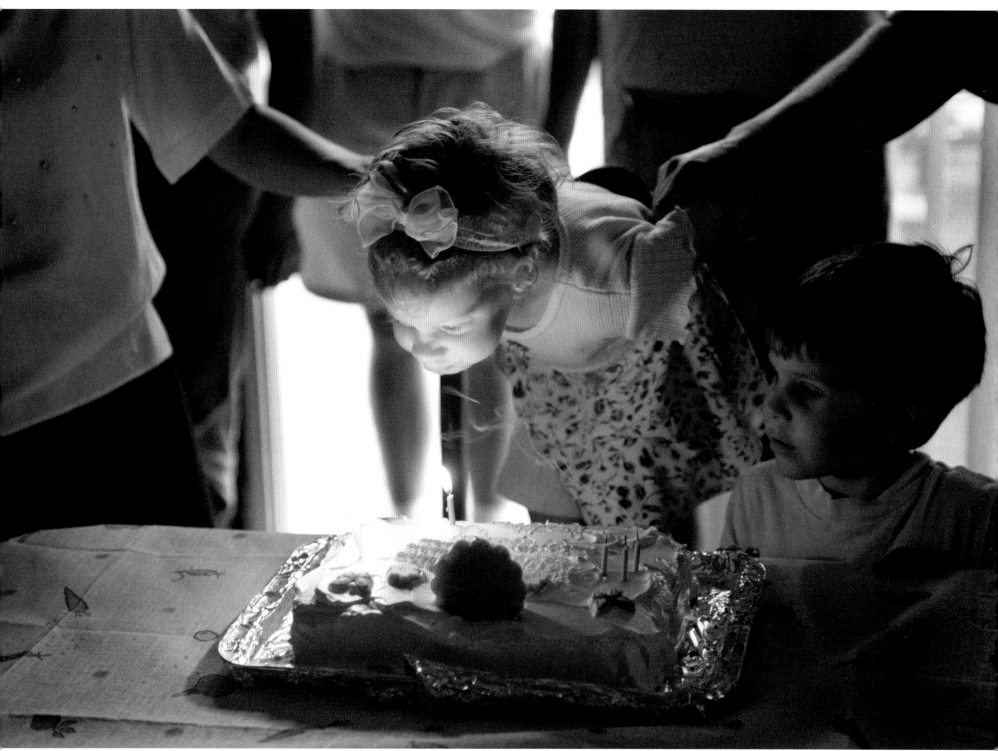

Birthday Wish

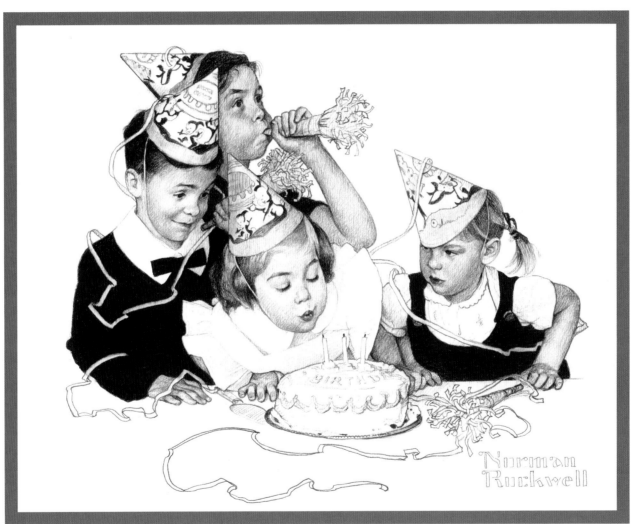

Birthday

ROCKWELL SHARED WITH

WALT DISNEY THE

EXTRAORDINARY

DISTINCTION OF BEING

ONE OF TWO ARTISTS

FAMILIAR TO NEARLY

EVERYONE IN THE U.S.,

RICH OR POOR,

BLACK OR WHITE,

MUSEUM GOER OR NOT,

ILLITERATE OR PH.D.

—Time *magazine, 1978*

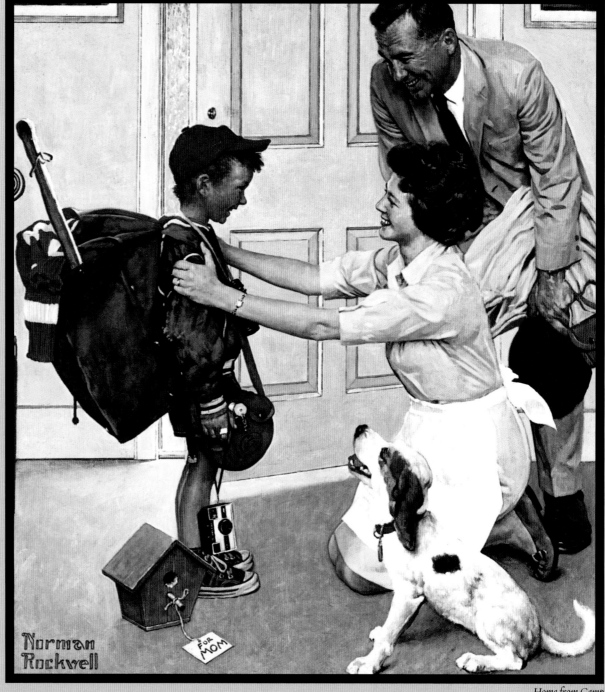

Home from Camp

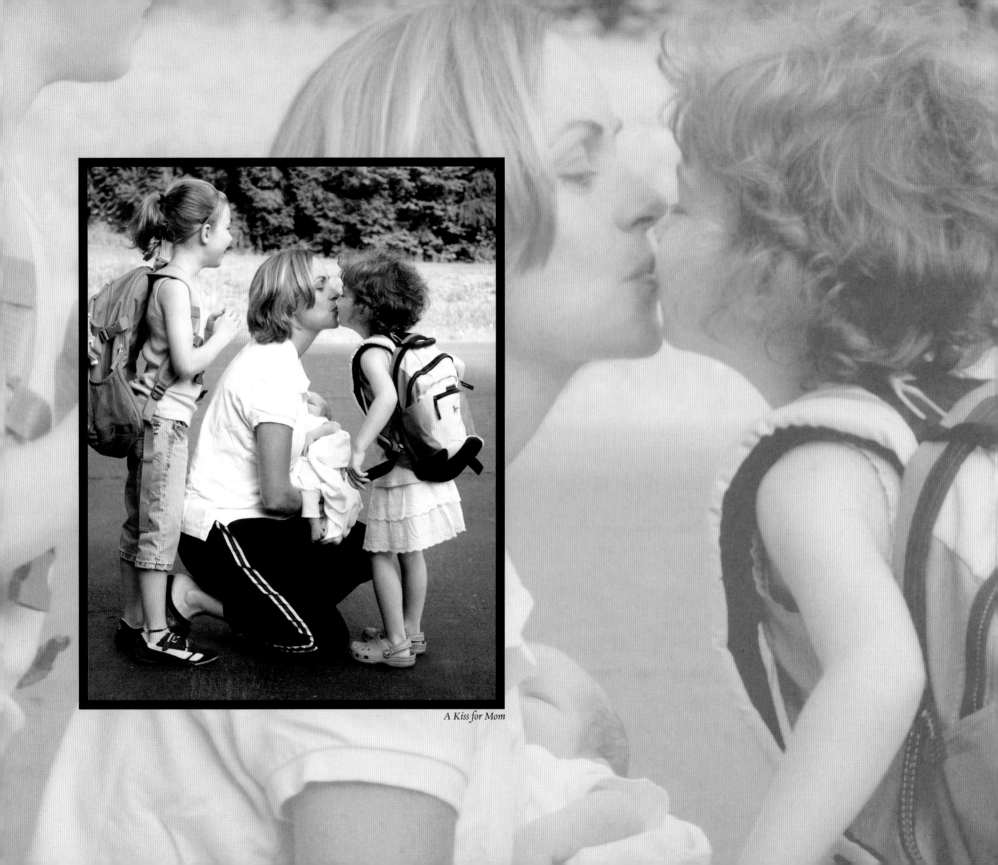

A Kiss for Mom

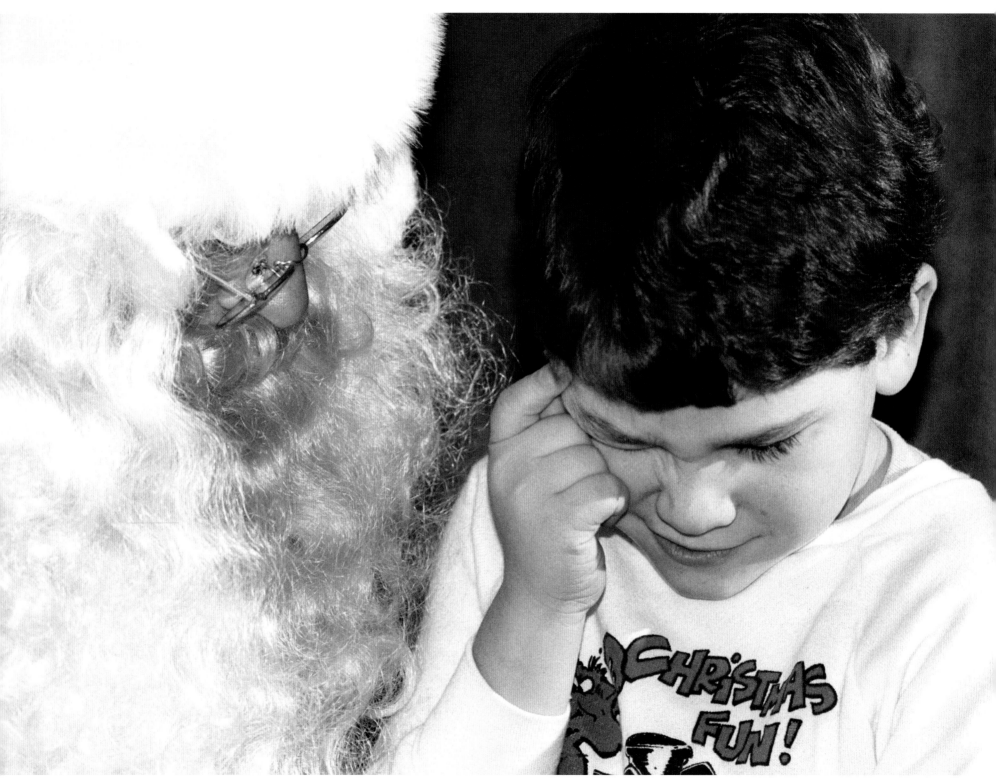

Santa Wants to Know

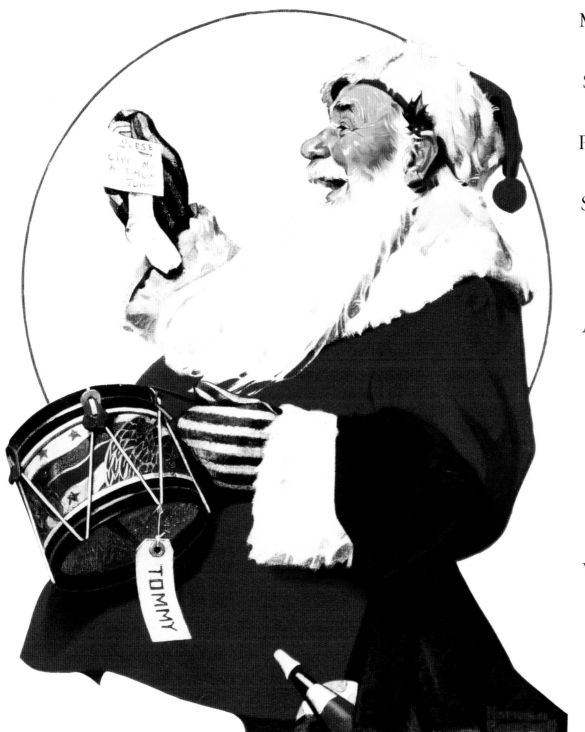

MY BROTHERS AND I HAVE
STARTLING MEMORIES OF
PEOPLE DRESSED IN SANTA
SUITS WIPING THE SWEAT
FROM THEIR FACES
AND DRINKING ICED TEA,
AND OUR MOTHER
HUNTING ALL OVER THE
HOUSE FOR CHRISTMAS
WRAPPING PAPER IN JULY.

—*Tom Rockwell*

"Christmas with My Father," Ladies' Home Journal,
*December 1988, p. 152. Rockwell was recounting the two
Christmas seasons a year in their home—the traditional one
celebrated each December and the one in July when the
national magazines' annual holiday covers were due.*

Drum for Tommy © 1921 SEPS

book return

donated by

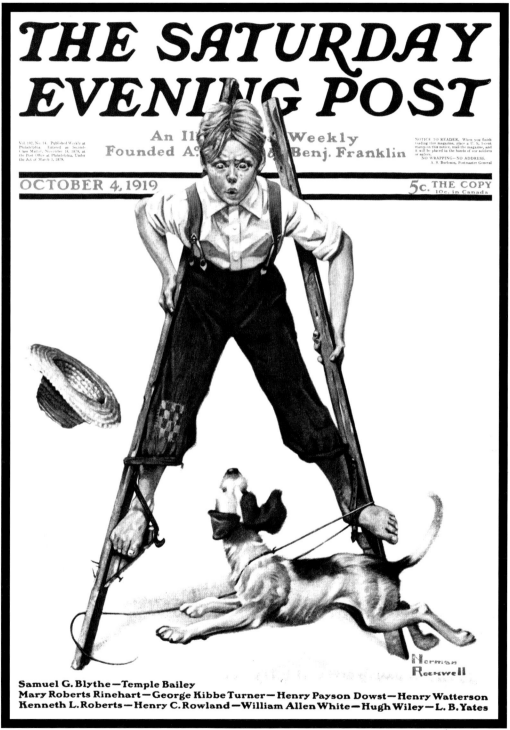

Stilts © 1919 SEPS

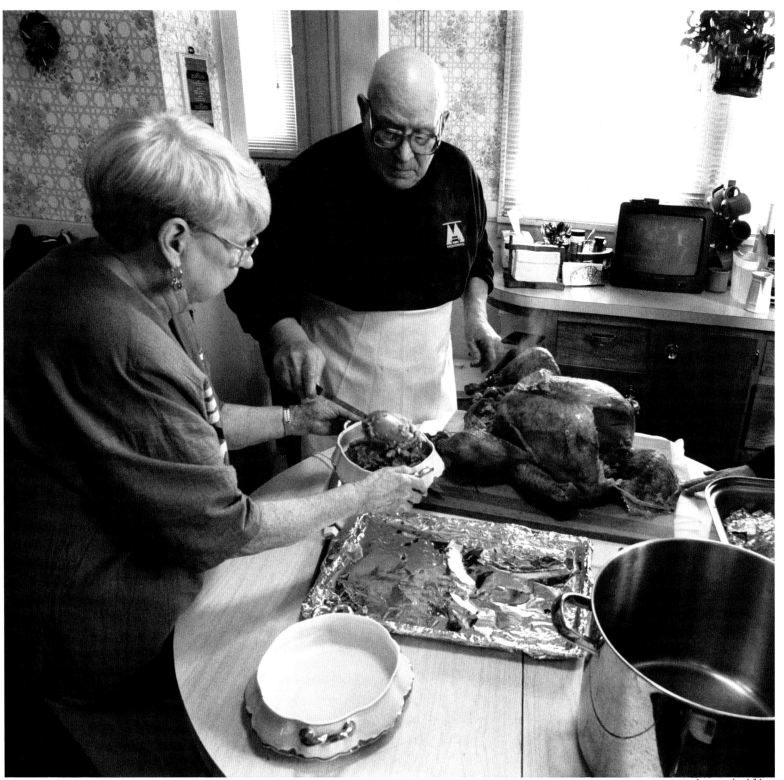

Much to Be Thankful For

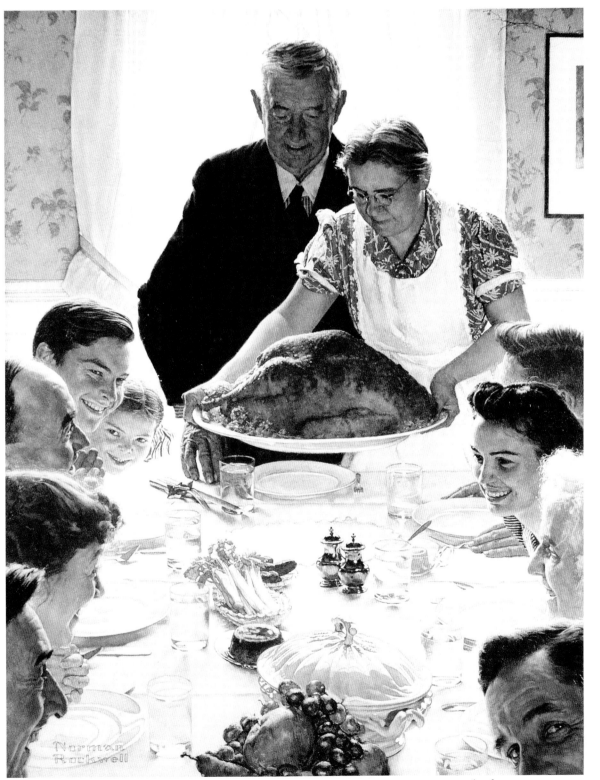

Freedom from Want © 1943 SEPS

The painting of the Thanksgiving dinner definitely established the ability of Norman Rockwell to capture a theme and make it work. When you see that painting, you know you're experiencing a happy Thanksgiving.

These moments in time that Norman Rockwell paints forever leave an imprint on your mind and heart.

—Ed McMahon
Entertainer and television personality

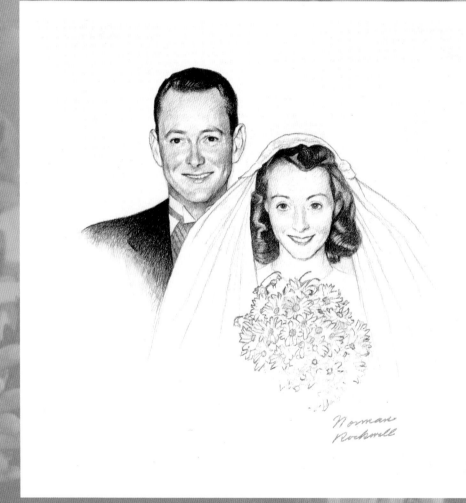

Marriage

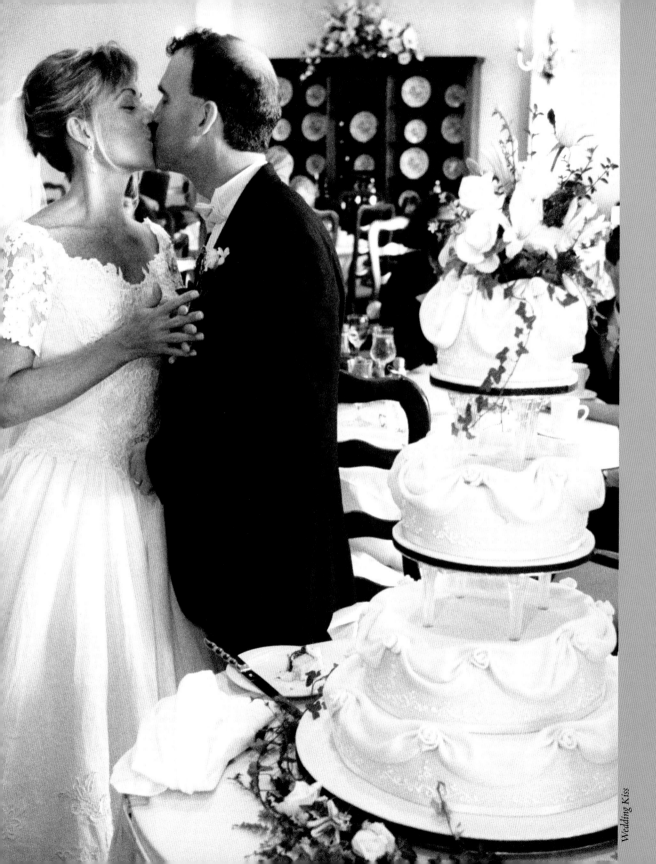

Wedding Kiss

Norman Rockwell inspired America by portraying everyday Americans in everyday settings in a way that we could all relate to. Rockwell captured the innocence, character, and soul of America through wit, satire, and insight. He paints with the quality of a master, has the insights of a prophet, and has the delivery of a genius. Norman Rockwell ranks among America's greatest artists.

—Rich Berg
CEO of Performance Trust Capital
Partners and collector of Rockwell artwork

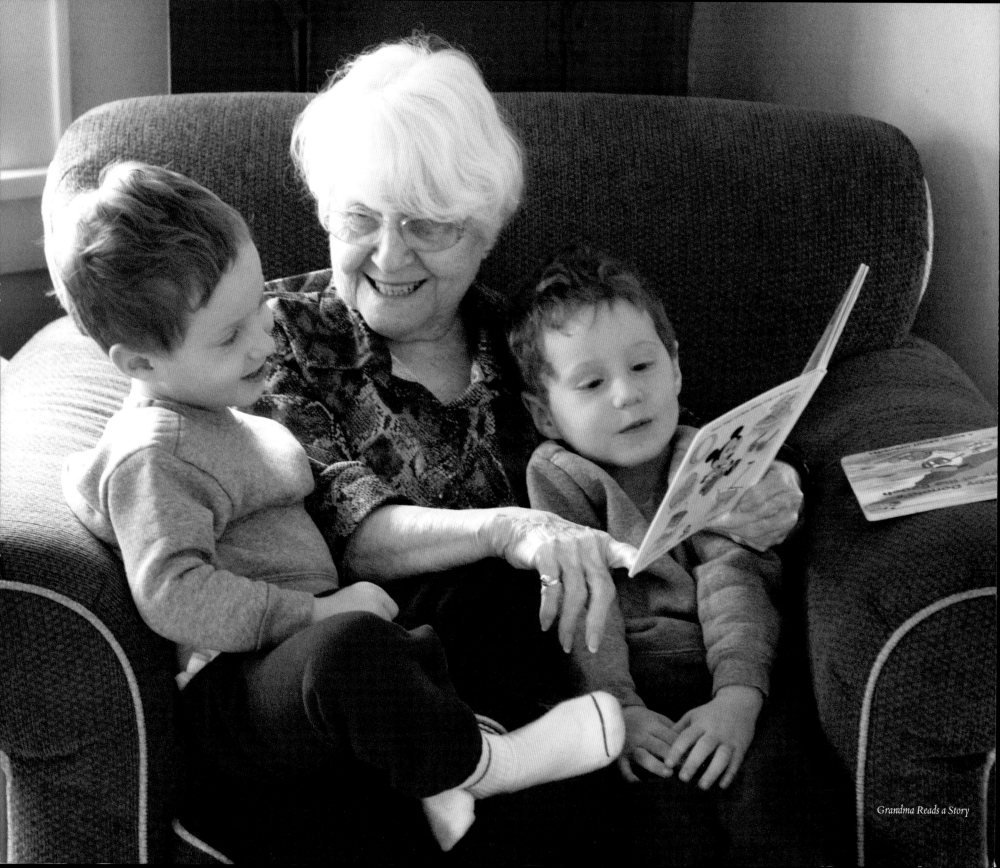

Grandma Reads a Story

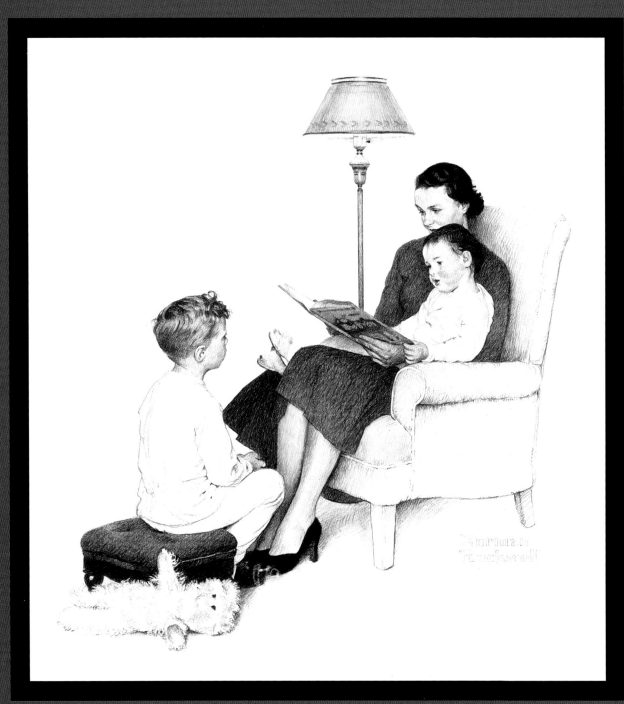

Mother Reading to Children

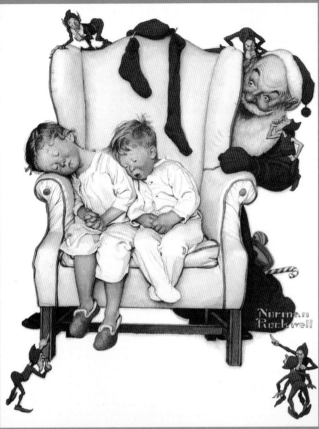

Santa Looking at Two Sleeping Children

Art in all forms is a means for us to express and understand who we are and what matters to us. "Rockwell moments" capture not only the wry humor in universal, everyday experience, but also let us glimpse the human connections upon which we thrive. Through Rockwell's pen and Rivoli's lens we see America at its best.

—*Donald J. Hall, Jr.*
President and CEO, Hallmark Cards, Inc.

Santa

When Winter Comes

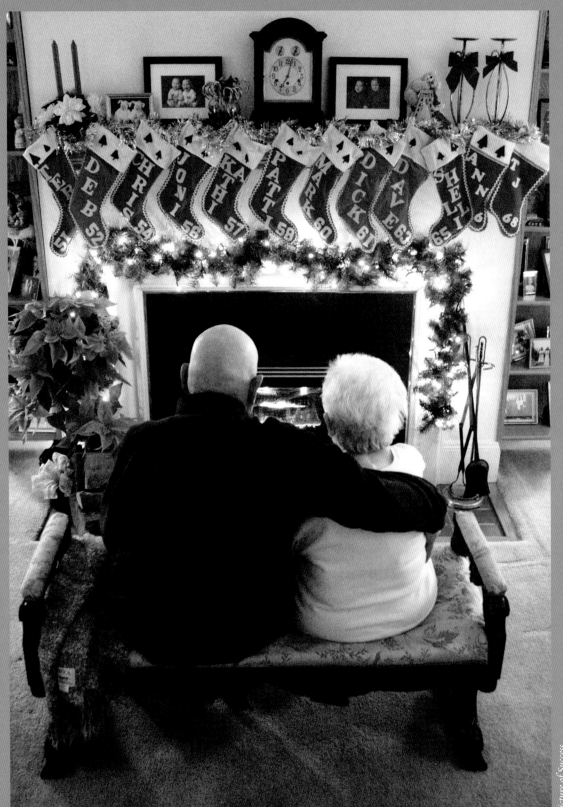

Picture of Success

FOR YEARS I HAVE GIVEN MY WIFE A ROCKWELL CALENDAR FOR CHRISTMAS BECAUSE I LOVE HOW NORMAN ROCKWELL FOCUSES ON FAMILY EVENTS THAT EVERYONE CAN RELATE TO.

—*Beau Bridges*
Emmy award-winning actor

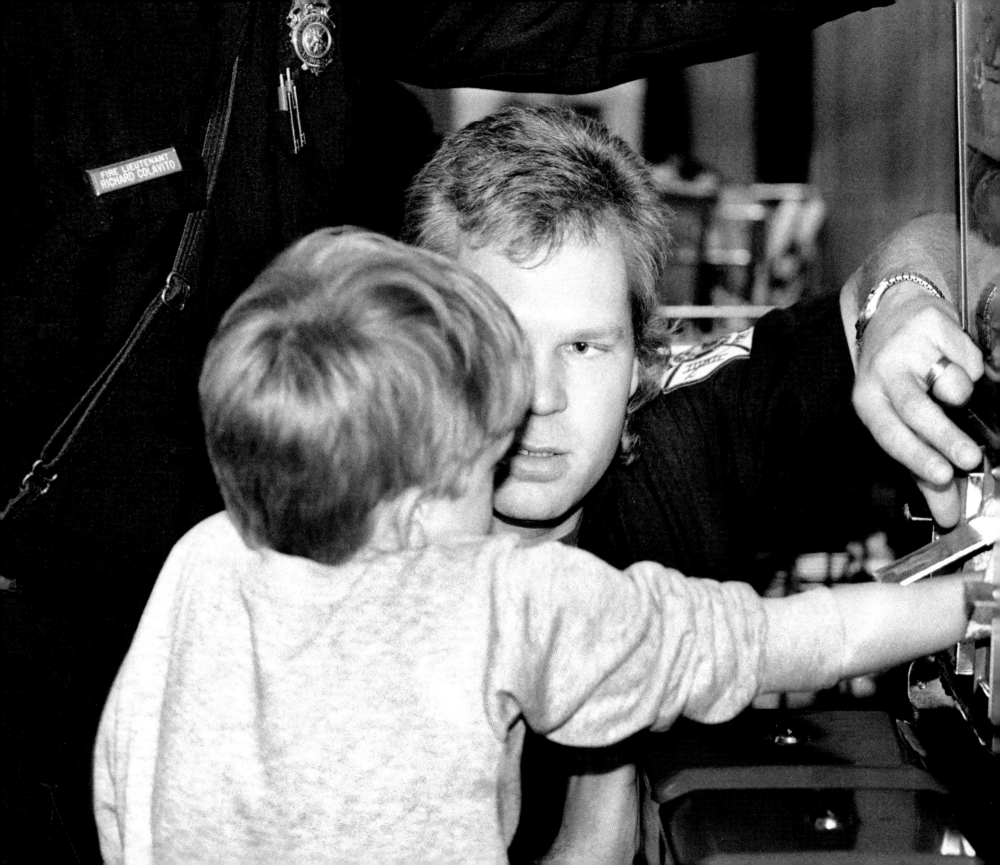

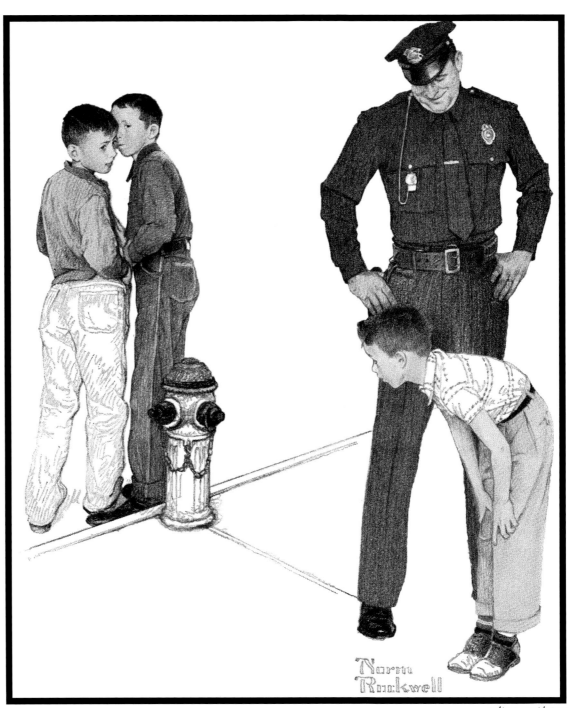

Policeman with Boys

HE WAS JUST MR. ROCKWELL

TO ME, THE NICE MAN

ACROSS THE STREET.

BUT TO MY FATHER,

DR. DONALD CAMPBELL,

MR. ROCKWELL WAS MORE

THAN A NEIGHBOR—

HE WAS ALSO

HIS PATIENT AND FRIEND.

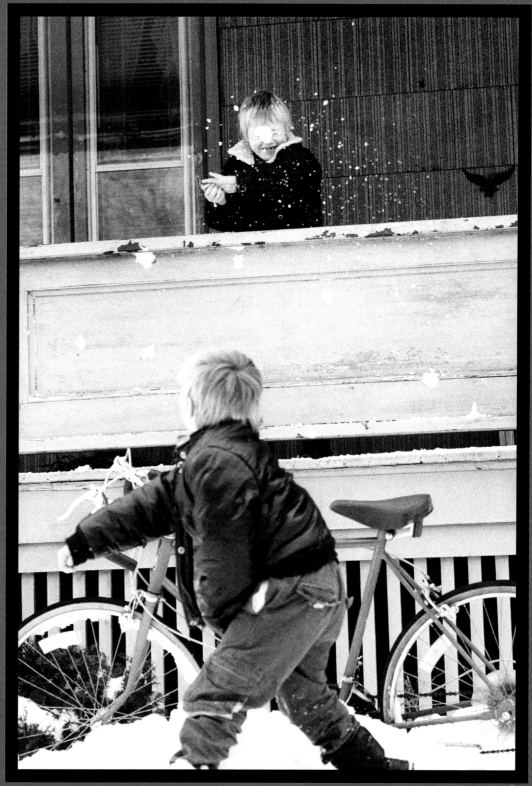

Bullseye

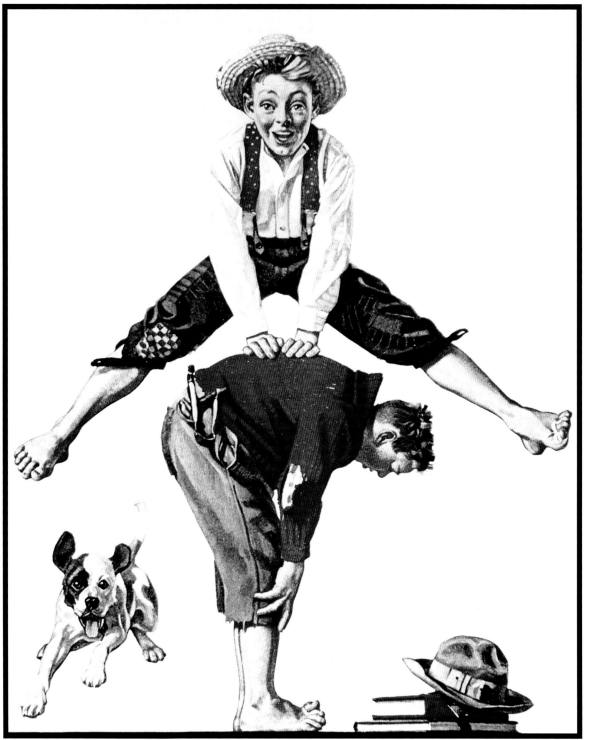

Leapfrog © 1919 SEPS

I have many great memories of Norman Rockwell from my childhood. Once, when I was very little, several dogs were chasing me down the street. I eventually fell off my bike and was terrified. Fortunately, I was in front of my neighbors' home—the home of Mary and Norman Rockwell. Mr. Rockwell came out and picked me up. He put me on his lap, and then drew me a cartoon. It starts out with a little girl riding her bike with dogs nipping at her feet. The little girl falls off her bike, and the cartoon ends with the dogs licking her face.

At that time, the Rockwells were no different from my other neighbors. I used to love visiting with Mary, but didn't really have an understanding of who Norman Rockwell was, as far as being a famous artist. He was just Mr. Rockwell to me, the nice man across the street. But to my father, Dr. Donald Campbell, Mr. Rockwell was more than a neighbor—he was also his patient and friend. My father and I posed for Mr. Rockwell on numerous occasions. My father modeled for, among others, the famous 1958 *Saturday Evening Post* cover titled *Before the Shot*. He's also the doctor in *Doctor and Boy Looking at Thermometer*, which was painted for Upjohn, the pharmaceutical company.

I have worked at the Norman Rockwell Museum for the past ten years. Norman Rockwell's paintings do reflect real life. I remember the circus coming to town and seeing the elephants for the first time. How many children had lemonade stands when they were growing up? That's something you still see today. Many of Mr. Rockwell's images depict small-town life the way he saw it, and he wanted to share with others what he was seeing.

—*Betsy Campbell Manning*
Neighbor and model for Norman Rockwell

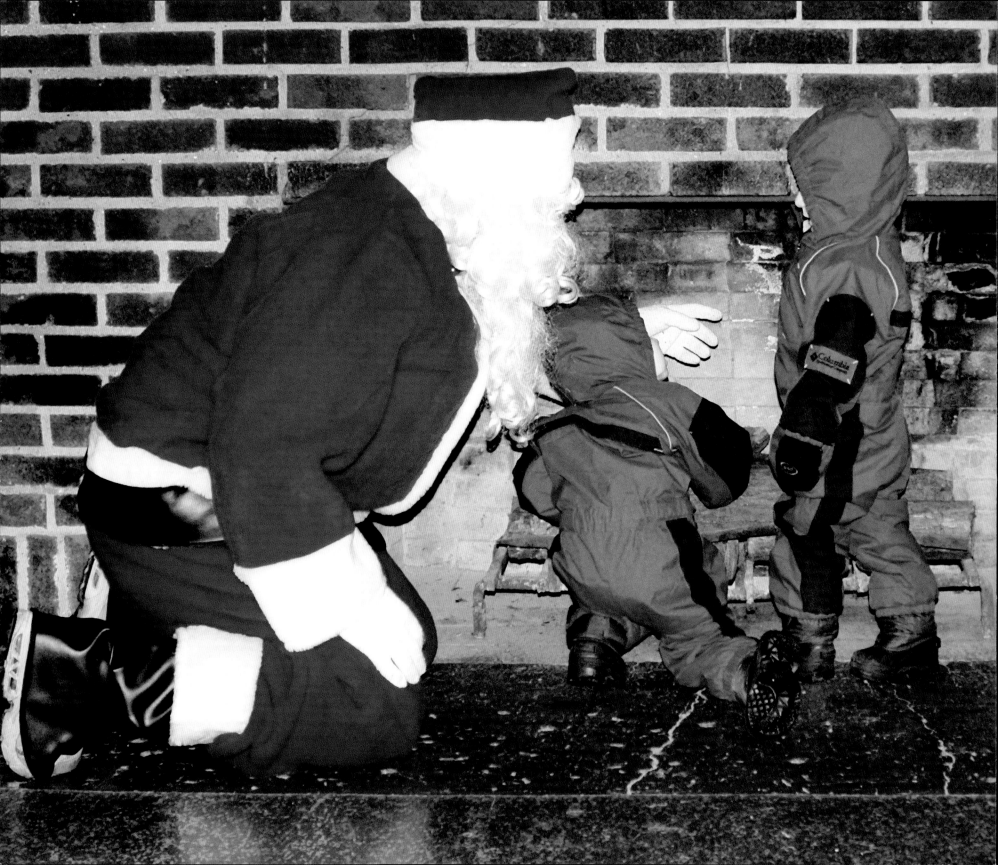

Santa Explains

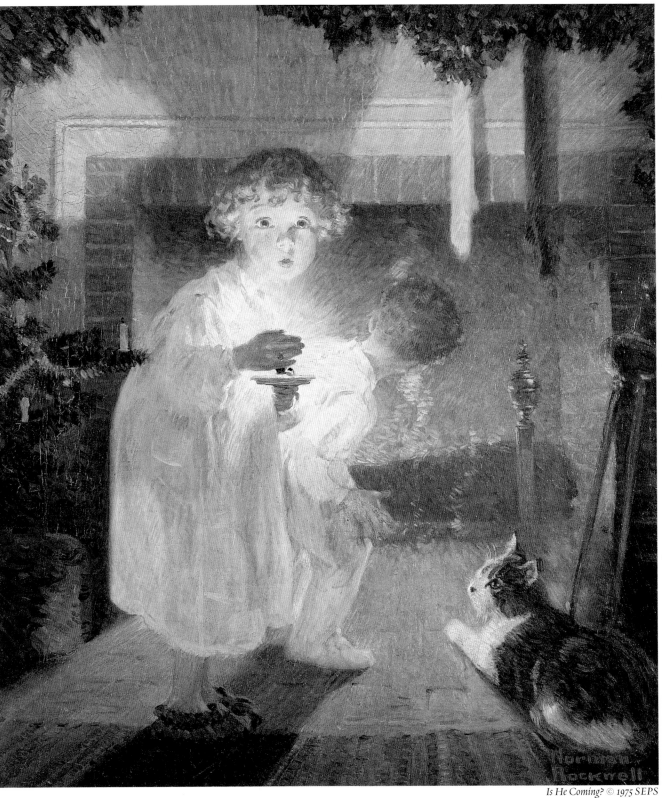

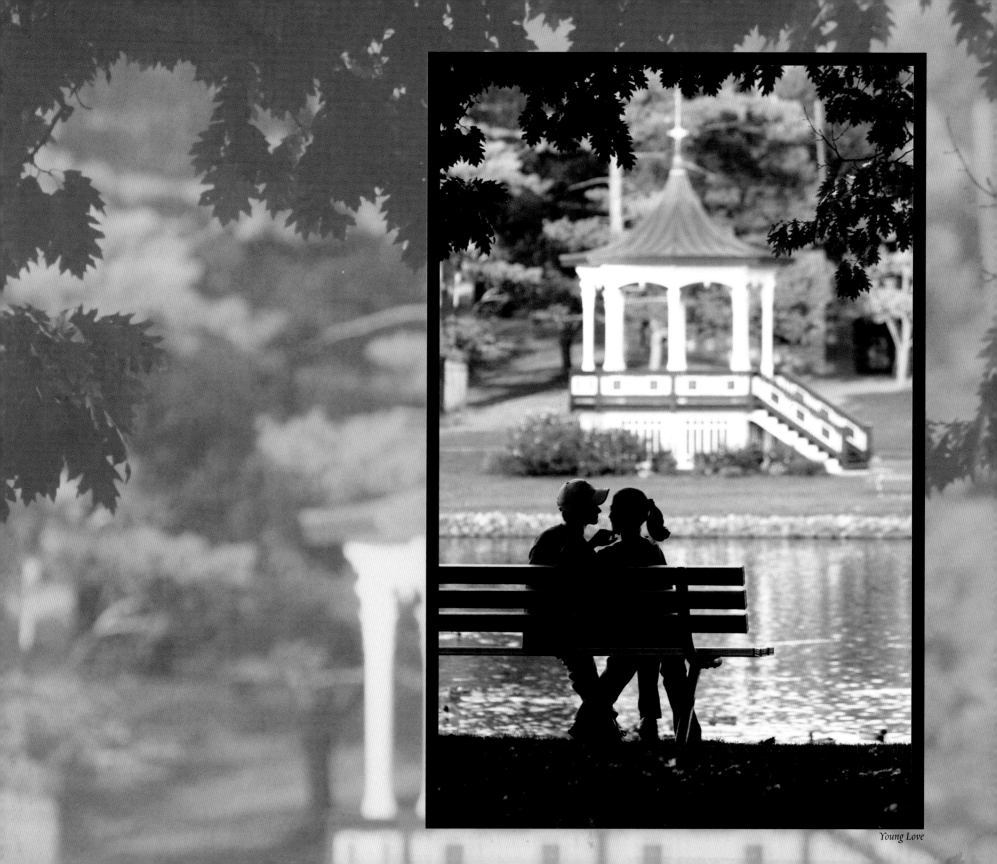

Young Love

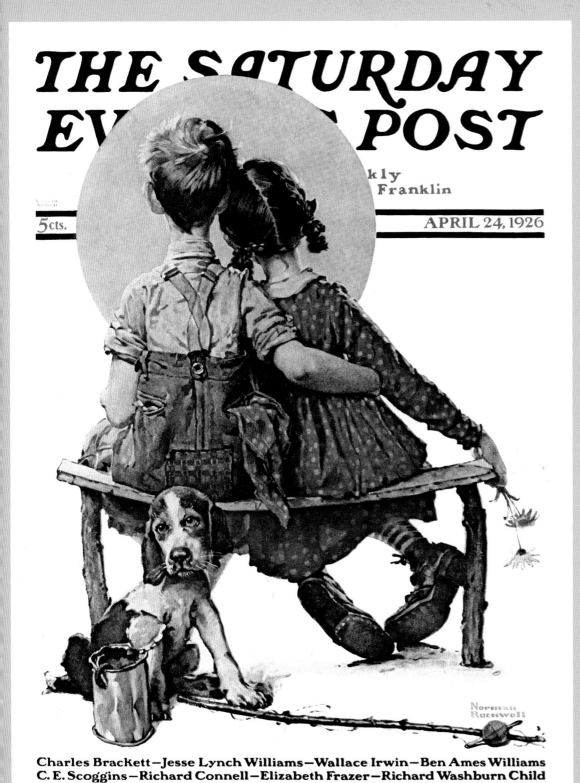

I'LL NEVER HAVE

ENOUGH TIME

TO PAINT ALL

THE PICTURES

I'D LIKE TO.

—*Norman Rockwell*

Published by Howard Books, a division of Simon & Schuster, Inc.
1230 Avenue of the Americas, New York, NY 10020
www.howardpublishing.com

In Search of Norman Rockwell's America © 2008 Kevin Rivoli
Foreword © 2008 Andrew L. Mendelson

ISBN-13: 978-1-4165-9547-2
ISBN-10: 1-4165-9547-3

10 9 8 7 6 5 4 3 2 1

HOWARD and colophon are registered trademarks of Simon & Schuster, Inc.

Manufactured in China

For information regarding special discounts for bulk purchases, please contact: Simon & Schuster Special Sales at 1-800-456-6798 or business@simonandschuster.com.

Edited by Chrys Howard
Cover design by Stephanie D. Walker and Cherlynne Li
Interior design by Stephanie D. Walker
Photography by Kevin Rivoli
Paintings and illustrations by Norman Rockwell

Notes to the Foreword by Andrew L. Mendelson:

1. Laurie Norton Moffatt, *Norman Rockwell: A Definitive Catalogue* (Stockbridge, Mass.: Norman Rockwell Museum at Stockbridge, 1986), xi–xii.

2. Quoted in Mary Anne Guitar, "A Closeup Visit with Norman Rockwell," *Design* 62 (1960), 28.

3. Christopher Finch, *Norman Rockwell's America* (New York: Abrams, 1975), 97.

4. Michael Kimmelman, "Renaissance for a 'Lightweight,'" *The New York Times* (November 7, 1999), Section 2, 54.

5. Robert B. Rhode and Floyd H. McCall, *Press Photography: Reporting with a Camera* (New York: Macmillan, 1961), 157–58.

6. Kenneth Kobre, *Photojournalism: The Professionals' Approach* (Somerville, Mass.: Curtin & London, 1980), 100.

7. Dave LaBelle, *The Great Picture Hunt: The Art and Ethics of Feature Picture Hunting* (Bowling Green, Ky.: Author, 1991), 27.